IMAGES
of America

BOXFORD

BOXFORD

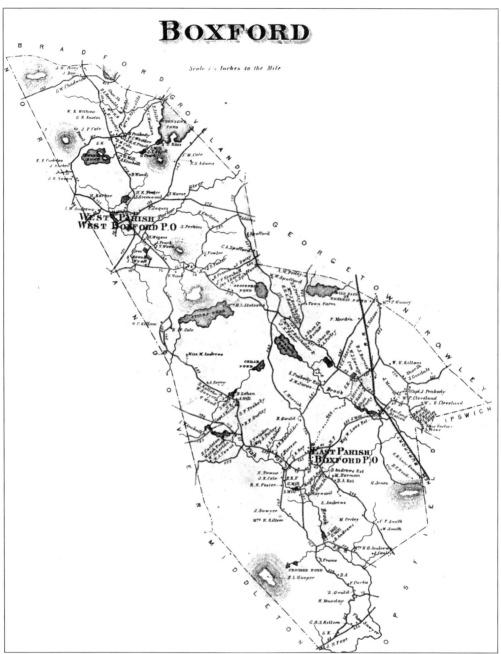

Scale 1½ Inches to the Mile

This map of Boxford, published in the D.G. Beers atlas of 1857, shows how the town looked when the population was 1,034 people. After the Civil War, the population gradually declined until, by 1925, only 581 people lived here. It was not until 1955 that the population again climbed over 1,000. In 1999, the town had 8,265 inhabitants.

IMAGES
of America

BOXFORD

Martha L. Clark and Brenda Moore Stickney

ARCADIA

Copyright © 2001 by Martha L. Clark and Brenda Moore Stickney.
ISBN 0-7385-0527-7

First printed in 2001.

Published by Arcadia Publishing,
an imprint of Tempus Publishing, Inc.
2A Cumberland Street
Charleston, SC 29401

Printed in Great Britain.

Library of Congress Catalog Card Number: 00-110177

For all general information contact Arcadia Publishing at:
Telephone 843-853-2070
Fax 843-853-0044
E-Mail sales@arcadiapublishing.com

For customer service and orders:
Toll-Free 1-888-313-2665

Visit us on the internet at http://www.arcadiapublishing.com

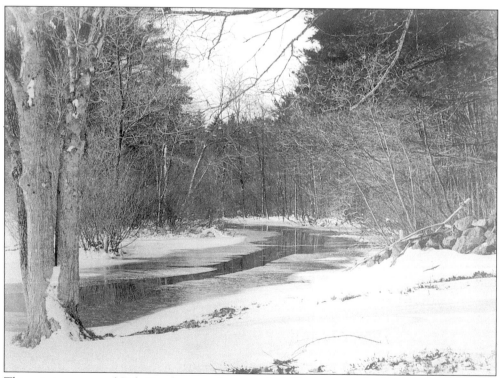

This winter scene of Fish Brook was taken nearly 100 years ago for Prof. George Herbert Palmer. The brook flowed through his property near 77 Main Street. Fish Brook was identified as "the Fishing Brook" in Boxford records as early as 1652.

CONTENTS

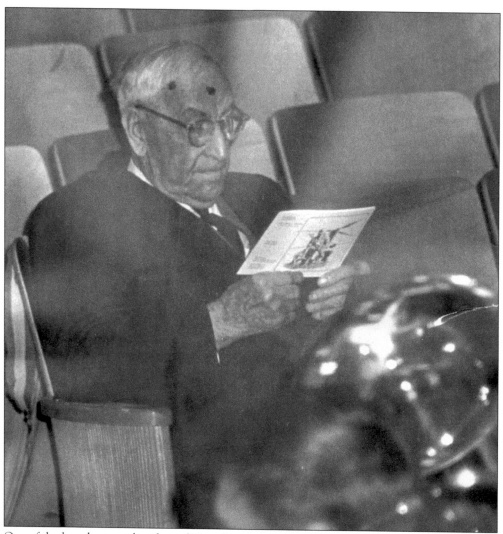

One of the last photographs taken of Harry Lee Cole was at the dedication of the James L. Melvin Post on April 12, 1970. A selectman for 61 years, Cole was often referred to as "Mr. Boxford."

Acknowledgments

Thanks to all of the generous people who have donated their collections of photographs and papers to the Boxford Historic Document Center. Due to their selfless contributions, the Document Center has grown to be an invaluable resource for local historical research. Among those who donated the photographs that made this book possible are the following: Ed Cunningham, Dick Hopping, Charlie Killam, the Lord family, Stanwood Morss, Peggy Nelson, and Albert Perley.

INTRODUCTION

The area known today as Boxford, Massachusetts, was originally part of the settlement of Ipswich, which was settled in 1633 by John Winthrop, son of the governor of Massachusetts. An Agawam Indian chief named Masconomet had laid claim to these lands, but surrendered his domain to Winthrop in 1638 for 20 pounds.

Sixty families, recent emigrants from Yorkshire, England, purchased land from Ipswich and Newbury, forming a new settlement called Rowley. The town, which was incorporated in 1639, encompassed a large area that included Bradford, Groveland, Georgetown, and Boxford. About a year later, six house lots were laid out between Fish and Pye Brooks. Abraham Redington, Robert Stiles, Joseph Bixby, John Cummings, William Foster, and John Peabody each took up their 30 acres in what became known as Rowley Village. The population continued to grow, and in 1666 two men were appointed to "lay out" all of the common land within the village boundaries. Those inhabitants with 2-acre house lots received 200 acres, and those with 1.5-acre lots received 67 acres. At the same time, settlers also began moving into the northwestern part of the village.

The residents worshiped at meetinghouses in Rowley, Topsfield, Bradford, or Andover. They soon tired of the long trip each week and wanted their own government and church. By 1685, there were 40 families living in the village, the minimum set by the Massachusetts General Court for incorporation as a town. They voted to petition the legislature for a town charter, and on August 12, 1685, the Massachusetts General Court approved the petition. The name Boxford was probably chosen to honor Rowley's minister, Rev. Samuel Phillips, who was born in Boxford, England.

In 1702, the first meetinghouse was erected and Rev. William Symmes was ordained as the first minister. Within 30 years however, the meetinghouse needed repairs. The inhabitants of the northern part of Boxford were reluctant to spend taxes to repair the meetinghouse because it was so far from their homes. They petitioned the court to form a distinct precinct, or parish. After much debate, the legislature agreed to establish the East (First) and West (Second) Parishes. The inhabitants were required to "support the minister" of their respective parishes. Specific geographic boundaries had been proposed in the approved petition, with the dividing line running through Stiles Pond.

Boxford was a thriving agricultural community through the mid-19th century. There were prosperous farms as well as supporting gristmills, sawmills, blacksmiths, and woodworkers. The nearby cities of Haverhill, Lawrence, and Salem provided good markets. The state census of 1875 reported 125 farms in Boxford; by 1880, half of the town's 12,000 acres of land was in pasturage. Less than ten percent of Boxford was forest. In fact, it was reported that the neighboring country and the Merrimack River's course could be seen for miles from several treeless "summits" in the West Parish.

By the end of the 19th century, the economy of the town had declined. Local industries had closed, and farming—especially in East Boxford—was much less profitable.

The completion of Interstate 95 in the 1950s provided easy access to Boston, altering the character of this tiny New England farming town forever. As a result of careful planning, conservation efforts, and early zoning bylaws, however, residents can still enjoy some of the same qualities that author Sidney Perley noted in *The History of Boxford, 1880:*

> As a whole, Boxford is a fine old farming town; pleasant to live in, healthy, and the many natural beauties of her landscapes, with the sweet warbling of the native songsters that inhabit the glades and the exquisite ferns in the spring unrolling from their woolly blankets, the cardinal flowers of late summer, the golden rod and asters of the autumn and all the lovely sisterhood of flowers which adorn our hills and meadows, give a continual glow of pleasure to the heart which loves the truly beautiful and the wonders of creation.

Authors' Notes

The continuing enigma of Boxford's geographical names deserves a brief explanation. Early documents refer to the two ends of town with designations of "north" and "south." They were also later described as First and Second Parish, or East and West Parish. On an 1884 map, the two villages that grew up around the First and Second Churches were called East Boxford and West Boxford. In recent years however, it has become customary to speak of East Boxford Village as Boxford Village, which has led to a good deal of confusion. Some speculate it was because the Boston and Maine Railroad station on Depot Road was referred to as Boxford. To further complicate matters, the depot area was subsequently labeled East Boxford on a 1940s map. This village labeling system, being technically and historically incorrect, is unfortunately repeated on the current U.S. Geological Survey maps. For consistency, we have chosen to refer to the villages as East Boxford Village and West Boxford Village and their outlying areas (as defined in the Massachusetts General Court's precinct description) as East Boxford and West Boxford, since these are the terms that were used during the period covered by most of the photographs in this book.

The format for the *Images of America* series justifiably limits the quantity of photographs that can be included in each book. Each photograph in this book was carefully chosen by the authors, with a great deal of thought given to quality, originality of subject matter, availability, and the photograph's ability to chronicle the history of Boxford in context with the others. Omissions are regrettable but necessary.

Long before the authors decided to create this book, each had been involved in separate historic preservation activities. Both have committed a portion of the proceeds from the sale of this book to benefit their respective efforts:

The privately supported Boxford Historic Document Center was established in 1976 to commemorate the bicentennial of the American Revolution. In this small brick building in West Boxford Village (see p. 24) is a fascinating collection of photographs, maps, documents, and books, accessible at no charge for public research. Most of the photographs in this book come from this intriguing collection.

In 1994, a tiny building known today as the Little Red Schoolhouse (see p. 76), was slated to be converted into modern municipal offices, complete with wall-to-wall carpeting and fluorescent lighting. A citizens' petition, led by one of the authors of this book, halted the inappropriate construction plans. The one-room schoolhouse received the honor of being placed on the National Register of Historic Places in 1998. Two years later, a nonprofit organization called Friends of the Little Red Schoolhouse was formed to raise funds to restore the building for use as a youth community center.

One

EAST BOXFORD VILLAGE

Dirt roads, elm trees, and open vistas characterize East Boxford Village in the early 20th century. The town hall (now the community center) was built in 1890 on the foundation of the earlier academy building. Farther down Elm Street, Howe's store is visible.

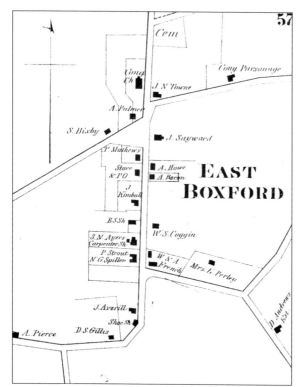

The D.G. Beers atlas, published in 1857, shows that the village included 17 houses, a shoe shop, blacksmith shop, and carpenter shop, along with the store and post office. Most of the houses in the village today were built by the time this atlas was published.

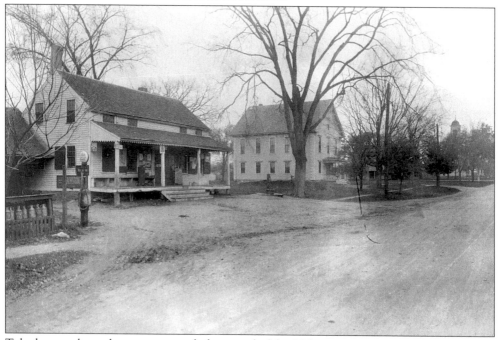

Telephone poles and a gas pump mark the arrival of the 20th century in East Boxford. The store was owned by Oliver M. Howe and rented to several different storekeepers, including Charles Bixby. Notice the milk cans near the gas pump waiting to be picked up and brought to the train station.

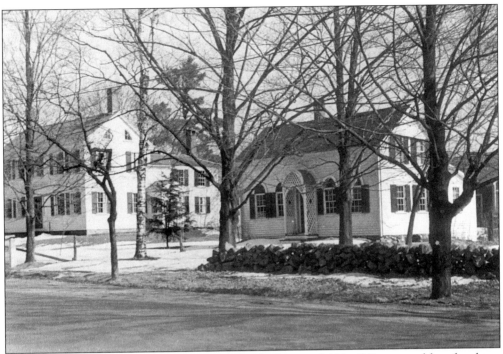

The small Bacon library (right) was originally the home of Abigail Bacon and her daughter, Abby. It housed the Boxford Public Library Association from 1880 until 1940. After Julia Cummings bequeathed her house to the association (left), the Bacon building was used briefly by the Boxford Historical Society, Red Cross volunteers, and as a residence for a pastor of the First Church. In 1947, it was sold and moved to Lynnfield.

This view of Elm Street looks from the store toward the south common. Electricity was introduced to East Boxford Village in 1916. The dirt roads, small trees along the roadsides, and lack of electric wires help date this photograph to the late 19th century.

The house at 9 Elm Street was built by Harry Cole shortly after his marriage to Ethel Killam in 1904. Several years of working in the store convinced Cole that he really wanted to be a farmer, so the family moved back to the Cole farm in West Boxford. Subsequent residents of this house included Clint French, John Bucyk, and the May family. (Courtesy of Marge May.)

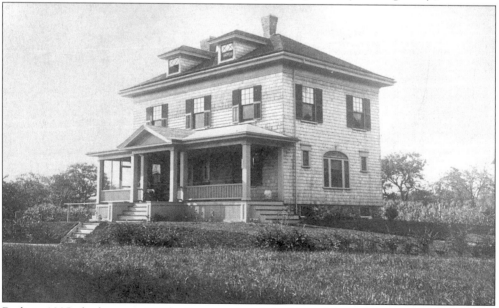

Built in 1905, the house at 21 Elm Street replaced the Henry Newhall house, which had been destroyed by fire in 1895. Newhall worked as a blacksmith between 1874 and 1895 in a shop near his house. This shop was torn down c. 1900, and the land was bought by C.D. Palmer, who built the present house.

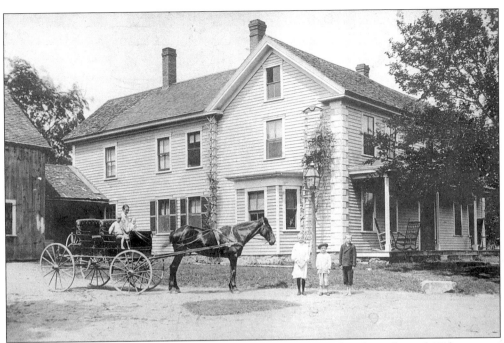

Portions of the Thomas Redington house at 13 Main Street may date from the mid-17th century, although the house was significantly altered at a later time. A number of different families lived in the house, and in 1868 it was sold to Daniel Gillis, who operated the Hotel Redington here. Gillis died in 1891 while he was lifting a trunk into a carriage. (Courtesy of Joan Walsh.)

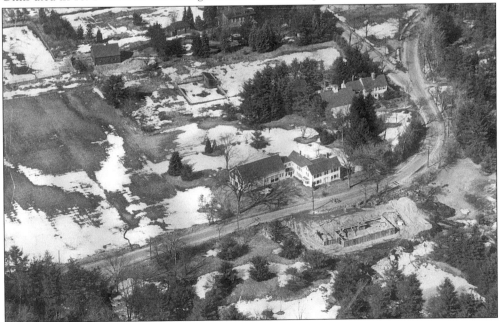

This photograph shows the open lands that surrounded East Boxford Village as late as 1969, when the house at 14 Main Street was under construction. The new house was situated on land marked by two stone posts that had been the croquet court for the Walshes, who lived at 13 Main Street. Also visible in the photograph is the house around the corner at 23 Elm Street.

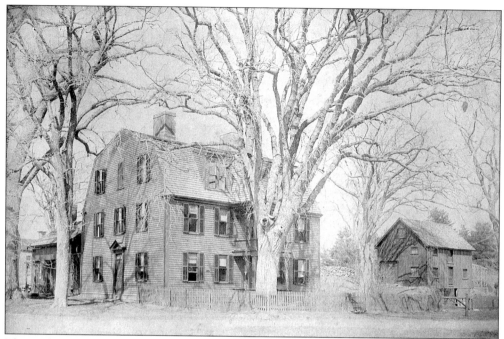

The Holyoke-French house, located at 2 Topsfield Road, was built in 1760 for Rev. Elizur Holyoke, the second pastor of the First Church. The house stayed in the Holyoke family until 1866, when it was sold to Elvin French after the death of Hannah Holyoke. By 1890, French significantly renovated the house, building the ell on the back, adding dormers to the roof, and constructing a two-story porch to the front.

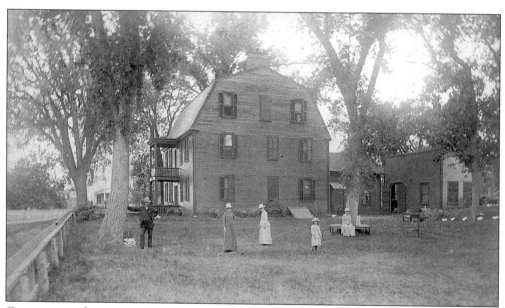

Croquet was a favorite summer pastime. Imagine playing under elms that had been set out 100 years earlier! According to Elvin French, the Holyokes planted seven elm saplings that they had dug out of Cedar Swamp, one representing each member of their family.

Three professional musicians lived at the Holyoke-French house. Samuel Holyoke, the eldest son of Reverend Holyoke, was a noted composer and music publisher. Both Elvin French and his daughter, Gertrude Holyoke French, were musicians who toured professionally. Gertrude, pictured here with her harp, bequeathed the house to the Boxford Historical Society on her death in 1942.

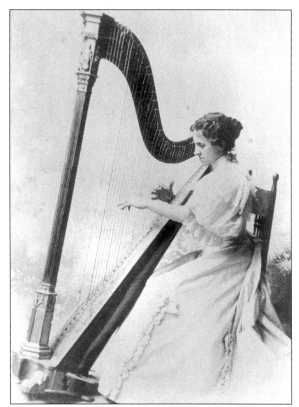

George Byam Parkhurst built the house at 16 Middleton Road c. 1910. Notice the matching shed in the back. George Parkhurst was the son of John Parkhurst, superintendent of the Byam and Carleton Match Factory, and the uncle of Amy and Winnifrid Parkhurst.

Thanks to Frank Manny, a writer and publisher who lived at 1 Middleton Road between 1919 and 1954, this house is one of the most photographed properties in Boxford. Built by Josiah Woodbury in 1817, the house had many owners, including Harvard professor Frederic D. Allen. The children of Professor Allen created a complex miniature village in a sand pile, which received much publicity. In 1973, Elizabeth Barnes Sawyer bequeathed the property to First Church Congregational.

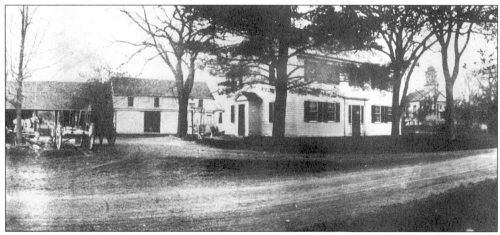

The house at 5 Middleton Road was built by Deacon Samuel Bixby in 1828. It remained in the Bixby family for four generations until 1937. Charles Bixby, the grandson of Deacon Samuel, kept the store in the village for many years in the early part of the 20th century.

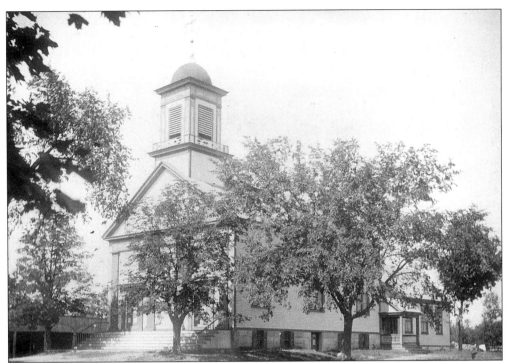

The third meetinghouse of the First Church Congregational (now known as First Church) was built in 1838 at a cost of $4,184.68 after a committee decided it would be too expensive to repair the existing one. Shortly after the completion of the new meetinghouse, new carriage sheds were also built. In 1895, the Coggin Memorial Chapel was dedicated, which also provided the church with a Sunday school library and pastor's study.

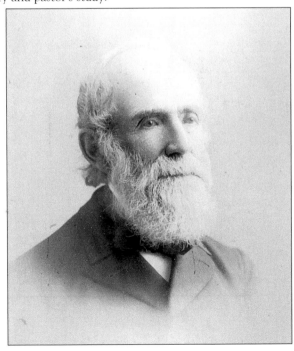

The Reverend William Symmes Coggin was ordained at the First Church on the same day that the third meetinghouse was dedicated. He ministered to the church from 1838 until 1868. After his retirement, Reverend Coggin was active in town affairs and also served as a representative to the Massachusetts General Court. He built the house at 14 Elm Street in 1842 and lived there until his death in 1895.

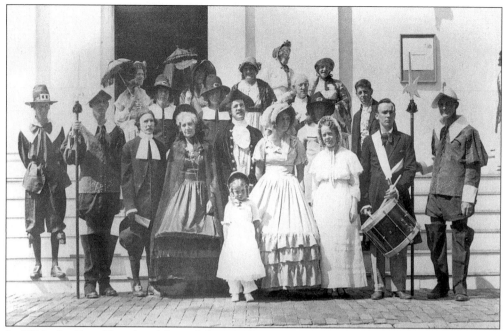

In 1938, the First Church celebrated the 100th anniversary of the third meetinghouse with a historical pageant. Standing on the steps of the church are, from left to right, the following participants: (front row) Paul Killam, Seth Kelsey, Jo Matthews, Edith Matthews, Winthrop Haynes, Marjorie Walsh, Ella Walsh, unidentified, Esther Perley, Franklin Roberts Jr., and "Hap" Moore; (middle row) Robert Little, unidentified, Rob Parkhurst, and Dwight Killam; (back row) Anna Haynes, Elizabeth Little, unidentified, Lucy Parkhurst, and Edith Parkhurst.

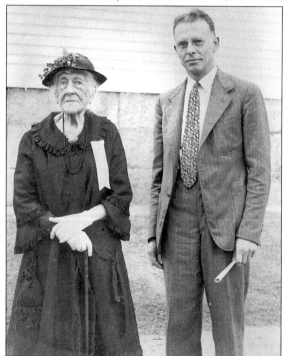

Also during the 1938 celebration, the First Church honored Martha Jane Gould Howe, shown here with Rev. Rolland Emerson Wolfe. "Aunt Jenny" was presented with a badge recognizing her 80 years of church membership.

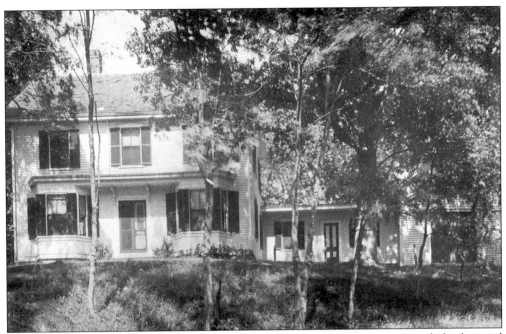

The First Church parsonage was built on Oak Hill (10 Depot Road) in 1869 with funds raised by subscription. Prior to that time, pastors had lived in their own houses. The church sold the parsonage in 1971.

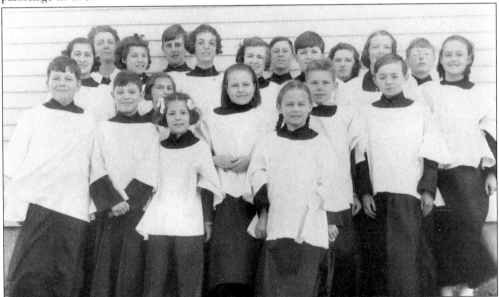

During the 1930s, while Rev. Rolland Wolfe was pastor of the First Church, a children's choir was established. The children were directed by organist Gladys MacPherson. They include, from left to right, the following: (first row) Edward Haynes, Frank Wolfe, Marie Little, and Coralie Childs; (second row) Ada Parkhurst, Mary Lou Waters, Palmer Little, and Edward Millen; (third row) Martha Mortimer, Betty Little, Kathryn Peabody, Barbara Millen, Alden Wadleigh, Jean MacPherson, and Sally Waters; (fourth row) Gladys MacPherson, Robert Parkhurst, Lester Abbott, Katherine Gamble, and Lewis Haynes.

In 1843, Dean Andrews built the Howe-Fort house at 20 Topsfield Road, near the site of a much earlier house. William Foster probably built the older house in 1660, and in 1687 he was licensed to keep an ordinary, or tavern. Town meetings were held here until the meetinghouse was built in 1702. In the late 19th century, the new house belonged to Solomon Howe, owner of the sawmill on Mill Road. Howe is shown on page 88.

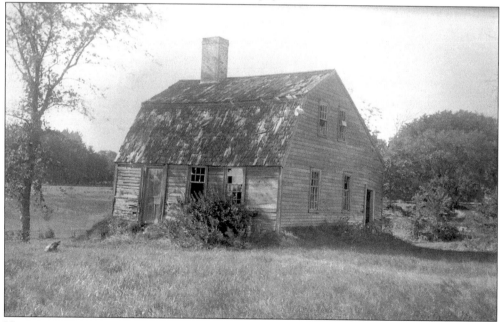

Honeymoon Cottage, an 18th-century house, stood near 29 Topsfield Road. By the late 19th century, when it was owned by Daniel Conant, it had been rented to many different families, hence its name. The cottage burned in September 1912.

Two
WEST BOXFORD VILLAGE

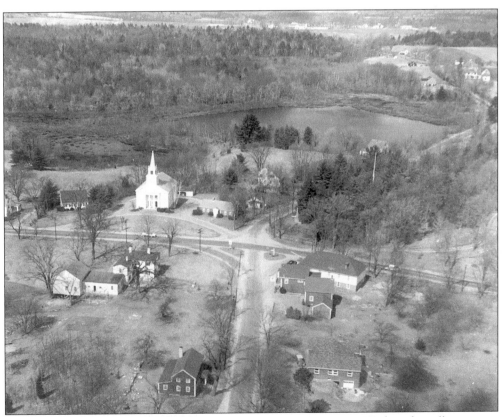

This aerial view of West Boxford Village was taken in the 1950s. Within the village, many landmarks are visible, including the Village Store, Lincoln Hall, Second Church and its parsonage, and the Ingalls Memorial Library. Beyond Sperry's Pond, Main Street wanders through open farmlands.

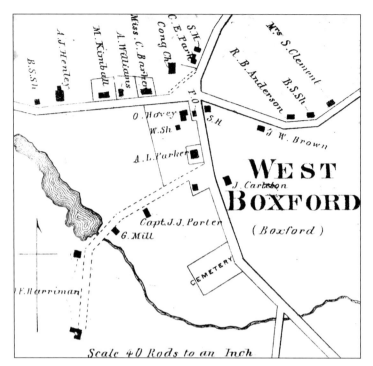

The 1857 D.G. Beers atlas shows the village, along with the millpond near Brook Road and Hasseltine's Brook (also called Porter's Brook). The village included two blacksmith shops, a gristmill, a woodworking shop, the post office, two schools, and 13 houses. At this time, the post office was located across Main Street from its current location.

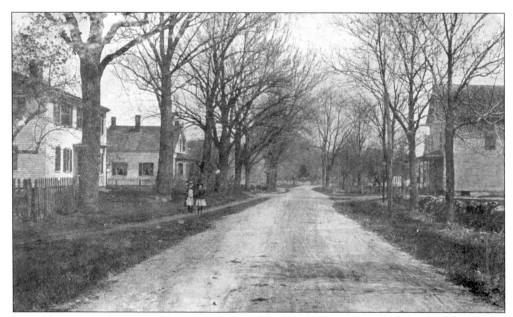

Probably published c. 1910, this postcard shows Washington Street, with Columbia Hall on the right, looking back toward the Soldiers' Monument and the center of the village. The two little girls on the sidewalk were members of the Golden family, who lived just outside the village in the old Peter Eaton house that burned in 1924.

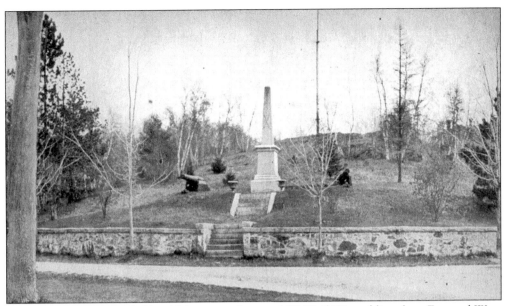

Dedicated in 1874, the Soldiers' Monument honored 27 Civil War soldiers from East and West Boxford who died during the war or shortly afterwards. Showing very few trees on Rocky Point, the postcard probably dates from *c*. 1908.

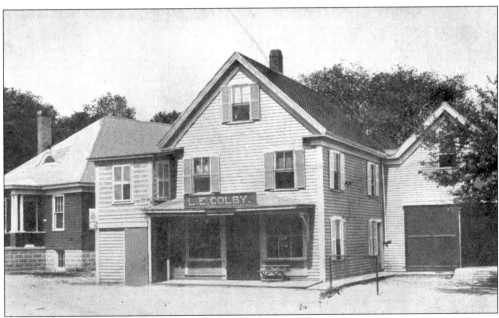

The store in the village was built in the early 1880s by E.E. Pearl. For many years, Gardner Morse owned the store. In the early 20th century, Leroy Colby ran it. Next-door, Lincoln Hall was built in 1912 by the West Boxford Development Corporation for use by the Grange and other social groups. Electricity was brought to West Boxford Village shortly after the construction of Lincoln Hall.

Like its counterpart in East Boxford, the West Boxford Library Association was a private organization that maintained the library with help from various fundraisers and half of the town's dog license fees. The Catherine Ingalls Memorial Library was built in 1930 to replace a much smaller building in back. (See p. 27 for a photograph of the first library.) In 1976, the Ingalls building became the home of the Boxford Historic Document Center.

Walter Renton Ingalls gave the library in memory of his daughter, Catherine Gordon Ingalls, who tragically died when she was 22. In this photograph, Ingalls is standing in front of the library in 1944 with Isabel Rounds, who served as the librarian for 20 years.

The house at 172 Washington Street was constructed in 1830 and has been owned by many different families. During the 1830s, the house was used as an inn. Around the time of this 1930s photograph, the property was owned by Robert Robinson, who built a gas station in front of the house on Washington Street. In 1974, when the Frizzel family lived here, the house was severely damaged by fire.

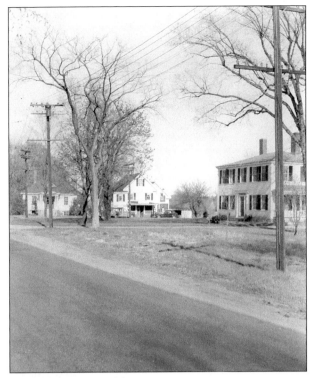

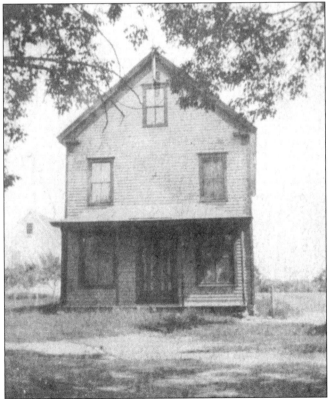

In 1870, D. Francis Harriman built Columbia Hall (also known as Harriman Hall) at 182 Washington Street. It had a store and post office on the first floor and large hall on the second. In 1915, Arthur Auger turned the building into a residence when the second floor was no longer considered strong enough for dancing.

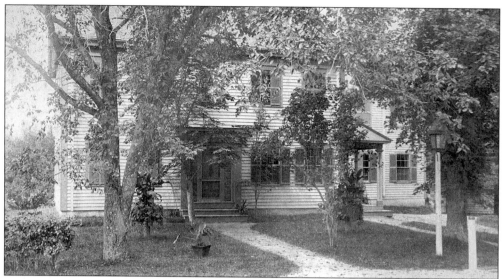

Calvin Park, pastor of the Second Church, bought his home at 570 Main Street in 1845 from the Second Parish. Although he resigned as pastor in 1859, Reverend Park continued to live in the house until 1893, when it was destroyed by fire. This picture, presented to Reverend Park by photographer Arthur Wilmarth, shows the original house. A second house was built and members of the Park family continued to live here until 1961.

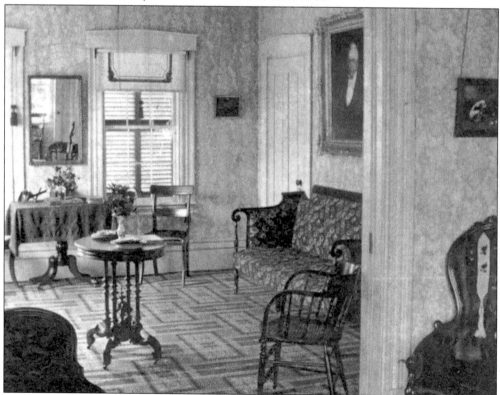

An interior view of the first Park house shows the front and back parlors. A portrait of Joseph Pope, father of Harriet Pope Park, hangs over the sofa.

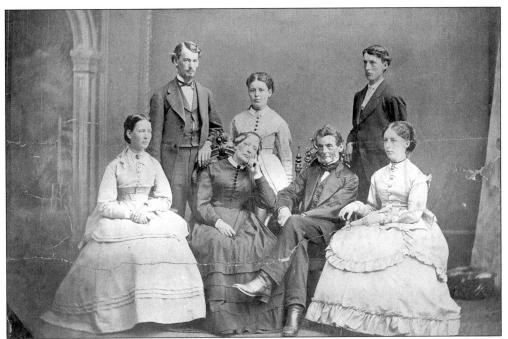

This Park family portrait includes, from left to right, the following: (seated) Anna Ballentine Park, Harriet Pope Park, Rev. Calvin Park, and Anna Park; (standing) Rev. Charles Park, Caroline Park, and William Park. Charles Park was a missionary in India, where he met his wife, Anna Ballentine.

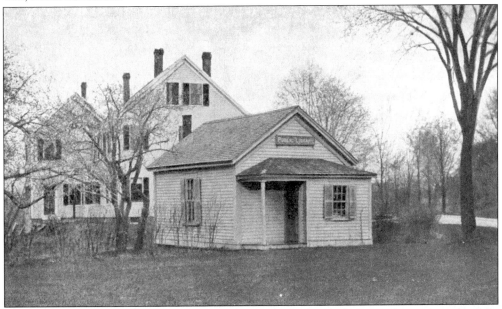

After Reverend Park resigned as minister of the Second Church, he opened a private school for boys. He taught the boys in a small schoolhouse in his front yard, and they boarded with Park's family. In 1885, the school was bought by the West Boxford Library Association; the building was moved and used as the library for 45 years until the Ingalls Memorial Library was constructed. The schoolhouse is now a small doll museum.

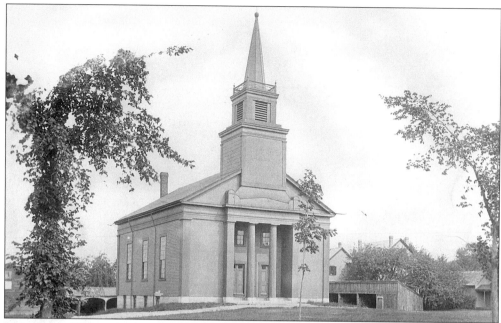

This Arthur Wilmarth photograph shows the Second Church as it looked in the 1880s. The horse sheds are visible around the back and side of the church, and Calvin Park's little school has been has been transformed into the library. The young elm trees along the common were set out at the request of Harriet Pope Park; most of them survived until the 1938 hurricane.

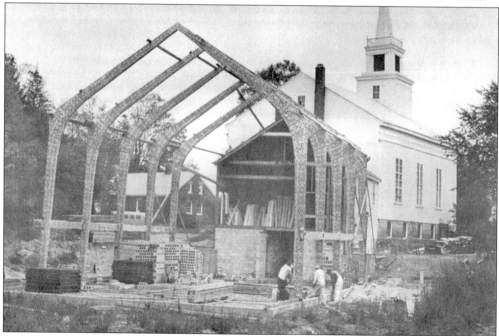

As in East Boxford, the Second Church has been housed in three different meetinghouses. Since the construction of the third in 1843, little had changed on the exterior of the church. In 1963, however, a growing church community and need for increased space led to the addition of a new wing. This 1964 photograph shows the framing of the new parish hall.

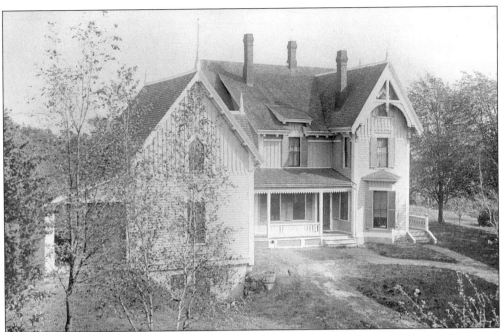

The Second Church parsonage, located on Rocky Point near the Soldiers' Monument, was built in 1875 at a cost of $5,000. This large Victorian house proved expensive to heat and maintain, so in 1943 the parish sold this parsonage and built a new, smaller house close to the church.

As part of the celebration of Boxford's 250th anniversary in 1935, the choir of the Second Church performed a pageant of quilts. In addition to the exquisite quilts, this view also shows the panel behind the pulpit with a painting of an open Bible and the saying, "The Opening of Thy Word Giveth Light."

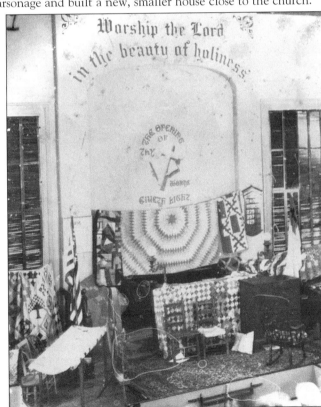

Elizabeth and Simeon Pearl were strong supporters of the Second Church and its various activities. Elizabeth Sanborn and her family arrived in West Boxford in 1906, when her father, Rev. F. Arthur Sanborn, became the new minister. In 1914, she married Simeon Pearl, whose ancestors arrived in West Boxford in 1738. In addition to writing numerous plays, Elizabeth also wrote the book *Memories of West Boxford*.

It was difficult to maintain the activities of the church in the early 20th century, when there were limited invested funds and farmers had irregular, often small incomes. Fundraising was creative and included auctions, plays, bake sales, and summer fairs. This auction dates from October 12, 1933.

Three

OUTLYING AREAS OF
EAST BOXFORD

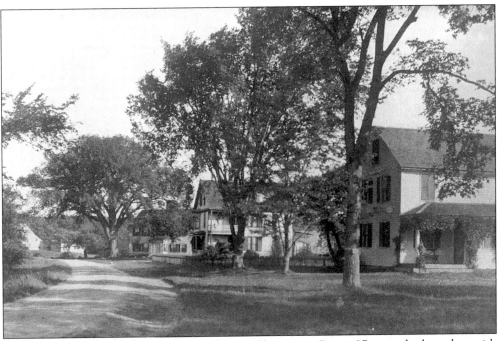

Howe Village is the name given to the cluster of houses on Route 97, near the boundary with Topsfield and Ipswich. Many of the houses were built or owned by members of the Howe and Hale families. This view shows the houses at 5, 7, and 9 Ipswich Road around 1900, before the road was moved away from the houses.

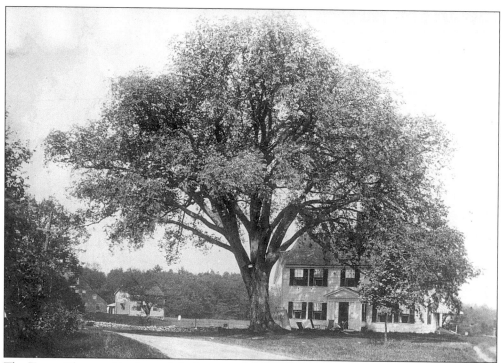

The Treaty Elm stood in front of the house at 9 Ipswich Road. In 1701, Boxford signed a treaty with the grandsons of Masconomet, who had also negotiated with several other towns in Essex County to confirm the original purchase of land by John Winthrop. In 1760, an elm sapling was set out to mark the location of the treaty signing. The tree stood for two centuries and was cut down in 1962.

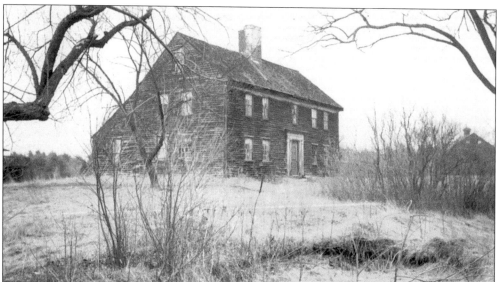

Around 1749, Joseph Hale built the residence now known as the Old Hale House, located at 15 Ipswich Road. Although the house remained in the Hale family until 1938, it was a tenement house and was rented to various people. It is reportedly the second oldest complete house in East Boxford.

Hidden down a lane off Ipswich Road, Cleaveland Farm was built by Aaron Perley *c.* 1818 on the site of an earlier house. Perley's daughter married William N. Cleaveland, and they moved to the house in 1856. Several generations later, the farm was the home of Mary Cleaveland, who taught music in the Boxford schools from 1894 until 1941.

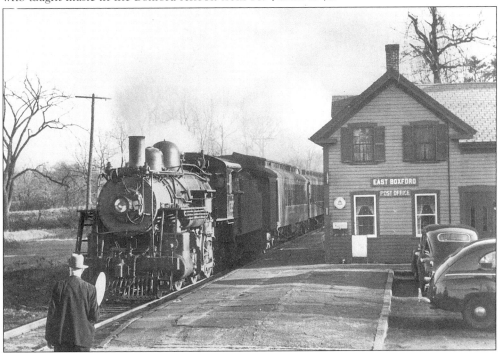

Yes, Boxford did have a train station; it was on the Newburyport branch of the Boston and Maine Railroad. The depot, located at 129 Depot Road, was built in 1853 and included the stationmaster's house. After 1889, the post office was also located at the depot. At one point, there were nine trains a day coming through Boxford, but ridership gradually decreased and the route was discontinued on December 13, 1941.

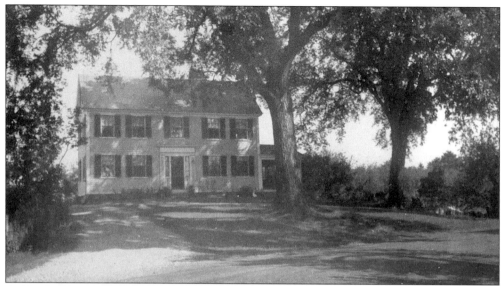

As Boxford became wealthier in the early 19th century, many of the older houses were either torn down, moved, or incorporated into more modern 19th-century dwellings. The Killam-Parkhurst house at 67 Ipswich Road was also built on the site of an earlier house. It was owned by T. Perley Killam from 1888 to 1954 and was inherited by his daughter, Lucy Killam Parkhurst.

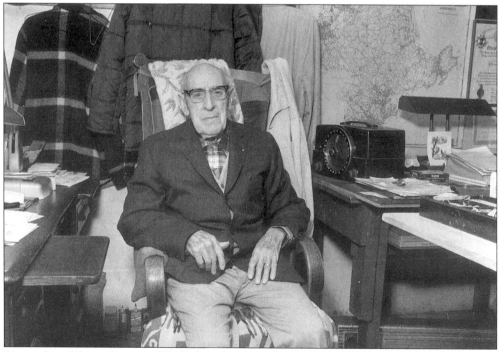

Pictured in 1980 at the age of 99, Robert Parkhurst lived in the Killam-Parkhurst house for 47 years. In 1973, Parkhurst was given the Boston Post Cane in recognition of being the oldest person in Boxford. He kept the cane for another 13 years. Parkhurst was well known as a surveyor, a job he continued until pneumonia forced him to retire at age 98.

At the turn of the 19th century, Depot Road was a quiet dirt road. In 1900, Boxford had a population of 704 people. As the population declined from its peak at mid-century, smaller farms were bought up, many of the houses torn down, and fields allowed to return to woodlands. This decline, however, gave Boxford an appealing rural atmosphere, and many people began to summer here.

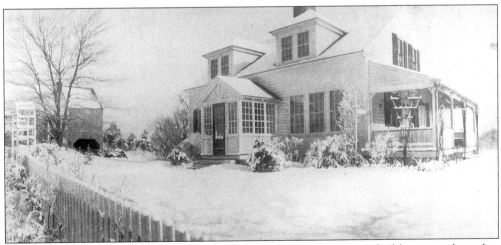

In the early 1950s, construction of Route 95 forced a number of Boxford houses to be either moved or torn down. The Moore-Adams house, built c. 1830, was moved from Killam Hill Road to its current location at the corner of Route 97 and Linebrook Road in Topsfield. The house was the summer residence of Harvard professor Charles Moore and was later owned by John Q. Adams.

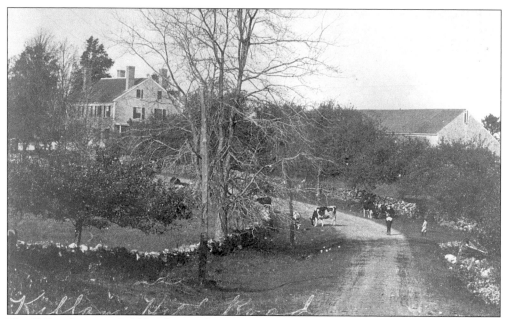

The Killam house at 2 Old Killam Hill Road was built by Thomas Perley *c.* 1810 with lumber his brother had cut in Bridgeton, Maine. In the summer of 1862, the house was used as an inn called Hotel Lander, well patronized by soldiers from nearby Camp Stanton. Several generations of Killams lived here from 1865 until 1956, when the construction of Route 95 sliced the farm in half and Paul Killam decided to move.

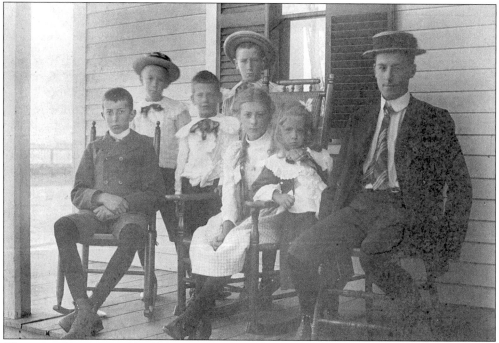

Chester and Minnie Tidd Killam lived in the Killam house for nearly 60 years. Seven of their nine children are pictured in 1902. From left to right, they include Raymond, Paul Lester, Horace Newcomb, John Leonard, Florence, Dwight Lewis, and Carl Killam.

The John Hale-Cadet House at 120 Ipswich Road dates from 1687, making it one of the oldest houses in East Boxford. In 1897, the house and farm were sold to the Salem Cadet Camp Association, which used the area for summer military training. The house was then known as the Cadet House; Lowe's Pond, behind the house, was often called Cadet Pond. Additional pictures of the Campground are found on pages 111 through 114.

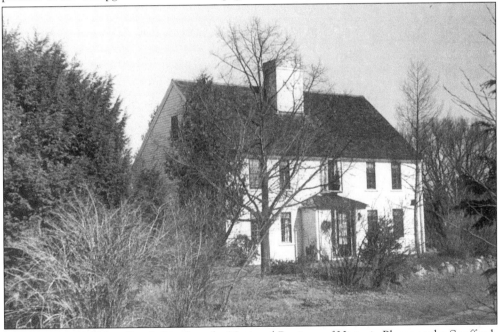

The house at 20 Kelsey Road, listed on the National Register of Historic Places as the Spofford-Barnes House, was built in 1749 by Paul Prichard. It was later owned by Benjamin Spofford and his son-in-law, Phineas Barnes. Chester Killam bought the property in 1912 and later sold it to Harlan P. Kelsey, who established a large nursery here. Several photographs of the nursery appear on pages 97 through 100.

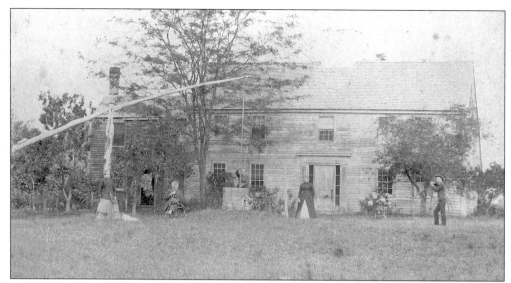

Many people will not recognize this photograph since they pass by the Janes house at 119 Bare Hill Road without ever seeing the front of the building. The rear section of this saltbox faces the road, and the distinctive outbuildings are across the street. The prominent well and sweep help identify early photographs of this house.

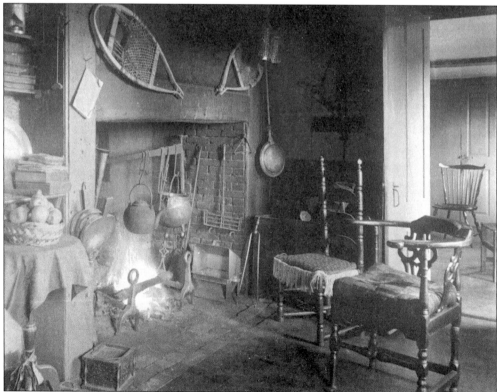

The front room of the Janes house is complete with snowshoes above the fireplace. Henry Janes bought the house in 1840, about 50 years after it was built on the site of an earlier house. Family members continued to live here until 1914.

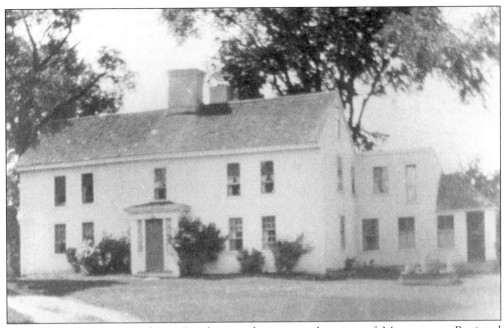

The Killam house on Endicott Road, near the present location of Masconomet Regional School, was located on part of the original land grant given to John Endecott by the Massachusetts General Court in 1639. In 1682, Zerubbabel Endecott built the house, which was sold to Thomas Killam in 1702. The house burned down on April 15, 1927, when it was owned by Franklin W. Killam.

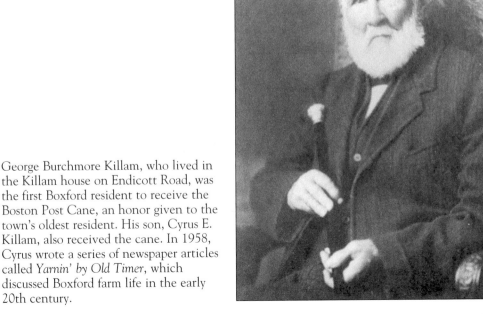

George Burchmore Killam, who lived in the Killam house on Endicott Road, was the first Boxford resident to receive the Boston Post Cane, an honor given to the town's oldest resident. His son, Cyrus E. Killam, also received the cane. In 1958, Cyrus wrote a series of newspaper articles called *Yarnin' by Old Timer*, which discussed Boxford farm life in the early 20th century.

The farm at 249B Middleton Road was owned by several generations of the Curtis family. When Francis Curtis died in 1829, his estate included 150 acres of land and buildings valued at $4,500. The house continued in the Curtis family until 1915, when Edward Jackson Holmes bought the property. In 1947, the Holmes family reimbursed the town to reroute Middleton Road to the back of their property.

Edward Jackson Holmes and his wife, Mary, summered at the Curtis farm for many years. Once Holmes retired as president of the Museum of Fine Arts in 1942, they made Boxford their permanent home. After their deaths, the farm was sold to developers who intended to build a golf course called the Boxford Country Club. It never opened due to inadequate funding, and eventually houses were built instead.

The house at 110 Middleton Road dates from 1750. It came into the Sawyer family in 1800 when John Sawyer married Sarah Killam. Sawyer's granddaughter, Mary Sawyer, lived in the house until her death in 1922. She had beautiful gardens and kept a daybook in which she recorded first sightings of various flowers and birds. She and her sister bequeathed 93 acres of their property to the Federation of Bird Clubs, which is now part of the state forest.

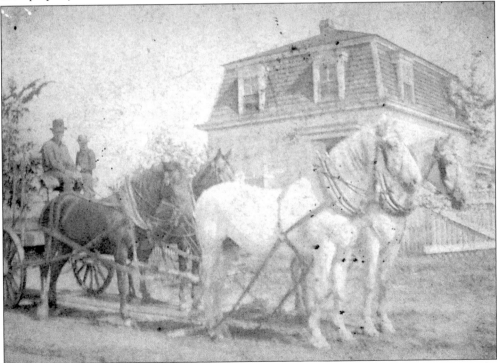

The little house at 40 Middleton Road, often called Emery's Gate, was the second house on the site. Samuel Frye built it in 1883 after the original house burned. The Fryes lived here until 1920, and the intersection of Main Street and Middleton Road was called Frye's Corner. The house was burned by the Boxford Fire Department in 1994.

The Haynes house, located at 57 Main Street, was probably built as a half-house *c*. 1680 and was enlarged in 1769 by Asa Redington. This picture shows it in the late 19th century, when it was owned by the Pearsons. In 1904, the house was sold to Lewis Kennedy Morse, a good friend of Prof. George Herbert Palmer. After Morse's death, his wife, Edna, donated land and Schoolhouse No. 2 (now known as the Little Red Schoolhouse) to the town for use as a playground and community house.

In 1925, the Morse's daughter, Anna, married Winthrop P. Haynes, a prominent geologist. Dr. Haynes's work took him to many places around the world, but in 1936 he brought his family back to Boxford and was very active in local affairs for the next 40 years. He is pictured on the left with Clarence Brown, who was the caretaker of the Haynes estate in the 1930s and 1940s.

Although the house at 77 Main Street was built in 1774 by John Willet, it was often called the Briggs house because Parson Briggs, fourth minister of the First Church, lived here between 1809 and 1833. Prof. George Herbert Palmer and his second wife, Alice Freeman Palmer (former president of Wellesley College), summered at the house beginning in 1884. In 1940, Bertha Palmer Lane and her daughter, Margaret, moved here permanently after spending many summers at the house next-door.

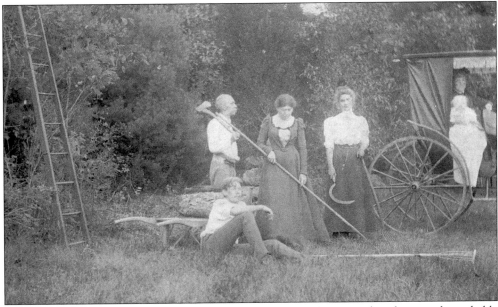

Professor Palmer and Lewis Morse were close friends and colleagues. This photograph, probably taken in the summer of 1902, shows the two families working together. The group includes, from left to right, Professor Palmer (with the ax), unidentified, Alice Freeman Palmer (holding the rake), unidentified, and Annie Hooker Morse with baby Arthur in the carriage.

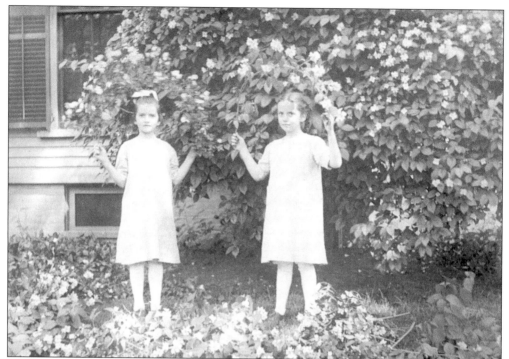

Margaret and Rosamond Lane grew up in Cambridge, but spent their summers in Boxford in the house at 85 Main Street. Rosamond married Milton Lord, director of the Boston Public Library, and raised her family here. Margaret, a librarian by profession, lived next-door. After her retirement, she was the archivist at the Boxford Historic Document Center from 1976 until 1991. This picture of the two girls dates from 1915.

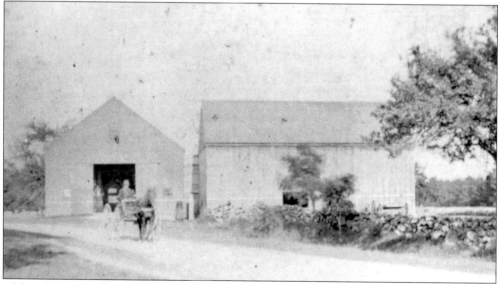

Although most 19th-century houses in Boxford had barns, there are only a few photographs of them. Perhaps the barns were mostly taken for granted like garages on our houses today. These two barns still stand across the street from 95 Main Street. The barn on the left was built by George Perley before 1880.

The three Perley sisters grew up in the house at 106 Main Street. Bertha Perley (left) was the librarian of the Boxford Public Library for more than 50 years. Barbara Perley was the town accountant from 1938 to 1972 and served as assistant assessor and assistant town clerk. She also coauthored two books about the history of Boxford. The oldest sister, Jeanette Perley (right), married Clarence Brown.

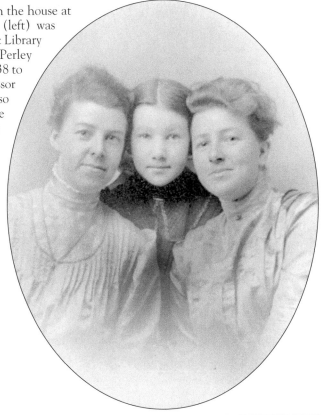

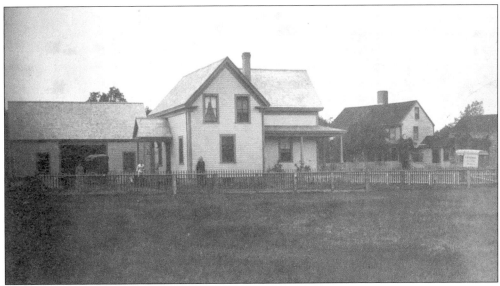

Rufus Emerson built the Perley house at 106 Main Street in 1884. A Civil War veteran, Emerson came to Boxford to work in the Byam and Carleton Match Factory with his brother-in-law, John Parkhurst. Emerson was also the superintendent of the town almshouse between 1880 and 1883. Sidney Perley wrote about Martha Parkhurst Emerson in his book *Poets of Essex County.* The three Perley sisters were granddaughters of the Emersons.

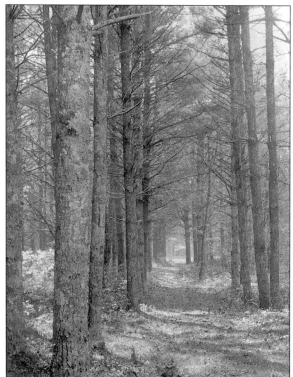

In the woods between Main Street and Fish Brook is the Fairy Ring, a natural opening in the forest where several pageants and plays were performed in the 1930s. Among the performances was *Time Will Tell*, written to celebrate the tercentenary of the founding of the Massachusetts Bay Colony. This path led to the Fairy Ring.

The Towne house, shown in 1900, is located at the end of Towne Road, overlooking Towne Pond. The house was built in 1790 by Asa Towne near the site of an older home, originally owned by the Smith family. Four generations of Townes lived in the house, the last being Hiram Towne, who died here in 1932. A large portion of his estate was then donated to Massachusetts and became part of the state forest.

The Parkhurst house, located at 29 Brookview Road, was probably built as a small, one-story house in 1702 and enlarged significantly in 1810. John Parkhurst, superintendent of the Byam and Carleton Match Factory, bought the farm for $1,800 around 1880. He later deeded it to his son, John W. Parkhurst, who lived here with his family. This early-20th-century view of the farm shows the house, barn, and outbuildings.

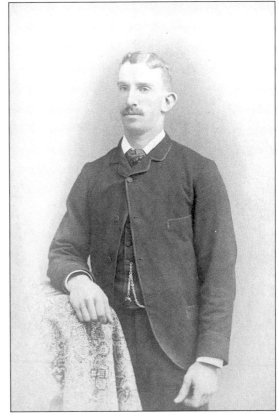

John W. Parkhurst lived at 29 Brookview Road from 1894 until his death at age 97 in 1959. A recipient of the Boston Post Cane, Parkhurst's service to his community was also notable for its longevity; he served as town clerk for 50 years and was deacon of the First Church for 60 years. He was keenly aware of Boxford's history and wrote about the match factory and Boxford's old roads. His daughters, Amy and Winnifrid, continued their father's interest in Boxford's history.

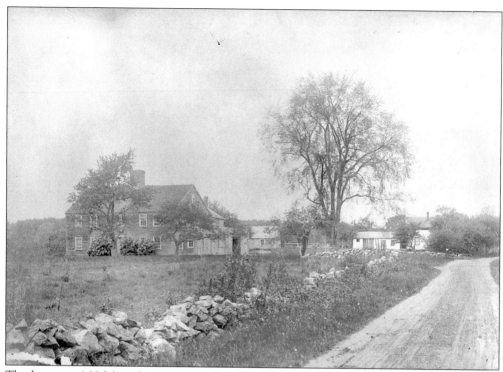

The house at 166 Main Street, now called Woodspell Farm, was built *c.* 1800 to replace an early-18th-century house on the same site. Rt. Rev. Henry Knox Sherrill bought the property in 1933 for his summer residence. After his retirement in 1958 as presiding bishop of the Episcopal Church in the United States, the Sherrills lived here permanently.

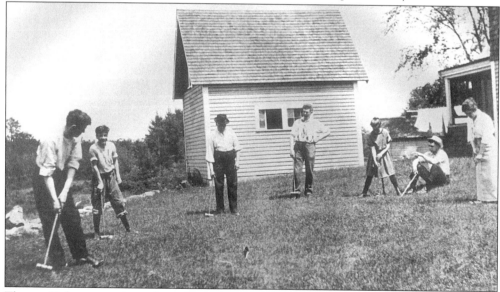

Thomas Holgate, superintendent of one of the mills in Lawrence, called his property Woodland Farm. The Holgates summered at 285 Main Street for many years. Their activities in Boxford are now well documented in photographs ranging from eating watermelon to haying and moving an outhouse. Here, they engage in a croquet game.

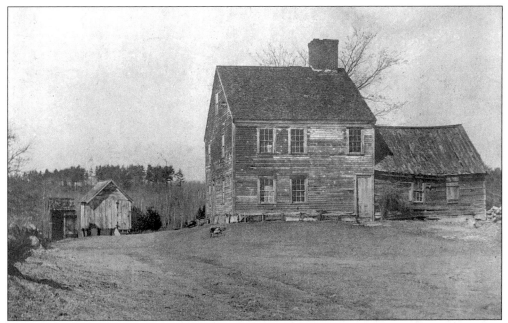

The house at Woodland Farm probably dates back to the early 18th century, when it was owned by several members of the Kimball family. It was situated at the beginning of a road that ran "from the training field to the north west end of town." Built in 1697, the road once went around the opposite end of Stiles Pond, near the present location of Camp Rotary, and came out near Witch Hollow Farm.

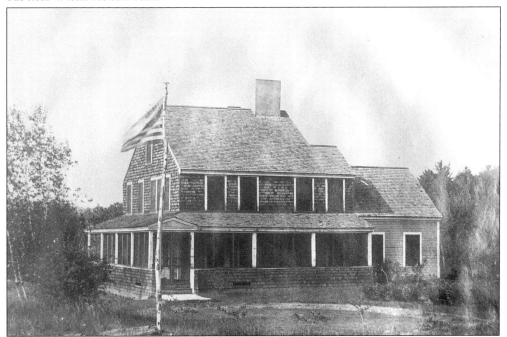

By 1917, the house had been substantially remodeled in the Shingle style, popular among summer cottages at the time. More frequently in the 20th century, early Boxford houses were bought by nonresidents for use as summerhouses, saved from ruin, and restored to their original appearance.

In 1888, Mary Adelaide Perley moved from Brooklyn, New York, to her new house at 48 Georgetown Road. William B. Howe and his wife, Martha Jane Gould Howe, bought the property in 1906 and stayed there until Mr. Howe died in 1930. "Aunt Jenny" Howe then moved next-door to live in her childhood home with her niece, Sarah H. Gerst.

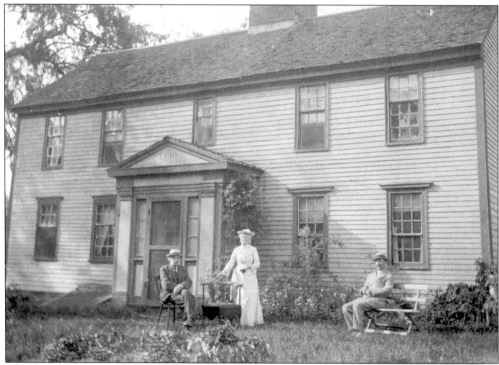

Painted above the door of the old saltbox at 54 Georgetown Road was the date 1740, the year the house was built by Benjamin Goodridge. Extensive plans and photographs were made of the house during the 1930s as part of the Historic American Buildings Survey. These proved useful in 1956, when the house burned down while being renovated. The new house on the site is a replica of the 1740 house.

The Peabody-Spiller house was located near 105 Georgetown Road. Capt. Stephen Peabody built the house in 1708. The first sawmill and gristmill in Boxford, built by William Peabody, was located near the house on Pye Brook. When the house burned down in 1910, neighbors immediately suspected the maid of arson, as her belongings were found across the street, untouched by the fire.

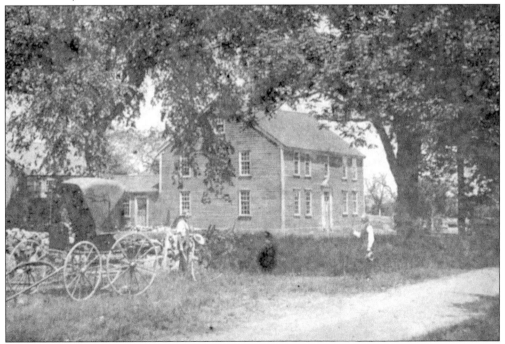

The old Butcher Peabody house was moved to its current location at 188 Georgetown Road in 1795 by Stephen Peabody. The house had stood on Ipswich Road near Harmony Cemetery, later the site of Schoolhouse No. 3. Peabody's son Samuel, a butcher by trade, lived in the house from 1830 until 1862, giving the house the name of Butcher Peabody.

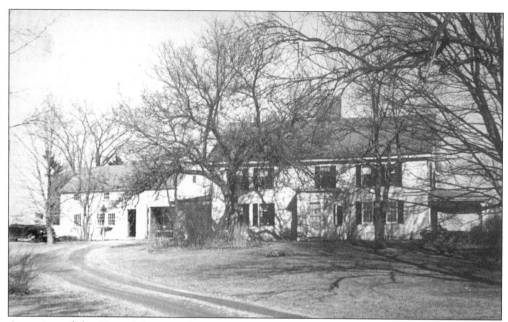

A section of the Herrick house, which used to stand at 5 Herrick Road, was built as early as 1660 by Joseph Bixby. In 1774, Gideon Bixby exchanged houses with John Herrick, who lived in East Boxford Village. The house continued in the Herrick family until 1964, when it was sold to William Dorman. The house was demolished at that point, when it was felt that it could not be successfully renovated.

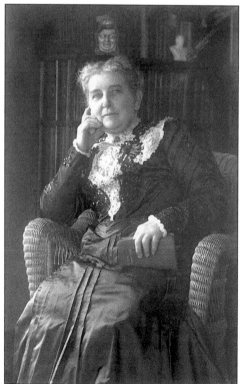

Mary Trask Herrick, the wife of Israel Herrick, lived at 5 Herrick Road until her death in 1910. Israel was quite prosperous, owning the sawmill on Lowe's Pond and 477 acres of property, valued in 1891 at $13,500. Their daughter, Mary A. Herrick, was a schoolteacher in Malden who lived in Boxford after her retirement.

Herrick Road dates from 1721 and has been known as Tyler's, Stickney, or Dresser Road. It was not completely paved until 1969. Prior to that, only the ends of the road were paved—to 5 Herrick Road on one end and to 131 Herrick Road on the other. The middle, with no houses, remained a quiet country road.

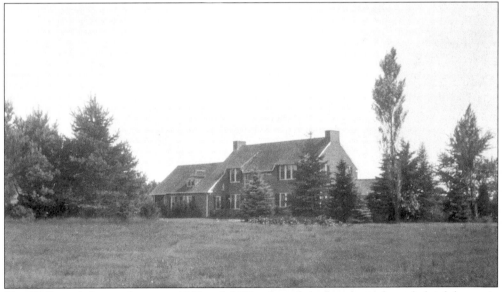

The William Atkinson house at 43 Topsfield Road was long known as the only brick house in Boxford. Atkinson was an architect who had studied at MIT and in Paris. He was also an accomplished pianist and composer. In 1921, the house that he designed had an assessed value of $5,000, making it one of the most expensive houses in town.

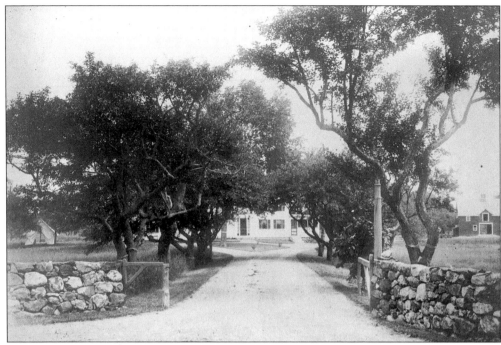

Five generations of Dormans lived in the Moses Dorman house at 42 Topsfield Road. The earliest section was built by Timothy Dorman in 1688, and a second section was added in 1729. Other changes were made in 1829 and 1850, so the house retains few features from the 17th century. Moses Dorman, who lived from 1765 to 1850, created the 1830 town map of Boxford.

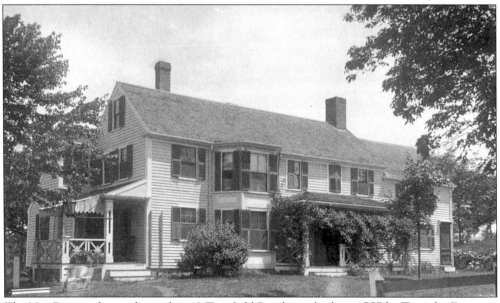

The Nat Dorman house, located at 48 Topsfield Road, was built in 1757 by Timothy Dorman, grandson of the man who built the earliest section of the Moses Dorman house. In 1825, an addition was built on the east end of the house, which included a one-story shed used as a carpenter's shop and small store. This 1929 photograph shows how the house looked before it was restored by Drs. Stephen and Charlotte Maddock.

Four

OUTLYING AREAS OF
WEST BOXFORD

Many of the West Boxford photographs in this book were taken by Arthur Wilmarth, who lived on Lake Shore Road in the late 19th century. Wilmarth took many landscape shots, providing compelling documentation of West Boxford at this time. This photograph shows Oak Ridge Road.

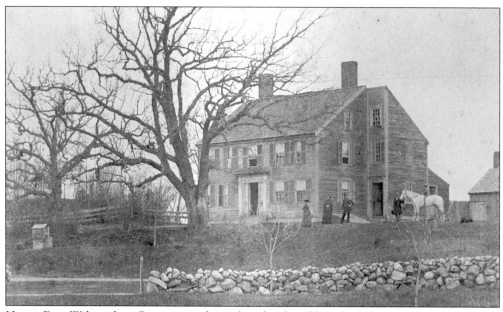

Henry Dan Wilmarth, a Boston merchant, bought the old Peabody house at 77 Lake Shore Road as a summer residence. His wife, Matilda Reynolds, was born in Hawaii, but grew up in West Boxford. This *c.* 1885 photograph shows the house before its restoration by the Wilmarths. The people include Mr. and Mrs. Wilmarth, and their neighbors, the Websters.

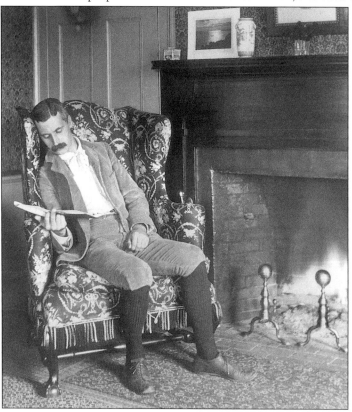

This is a self portrait of Arthur Wilmarth sitting by the fire, holding the bulb to release the shutter. Wilmarth's photographs, taken using glass-plate negatives, have a distinctive design to them, and some show a surprising sense of humor. Most of the glass-plate negatives were donated to the Boxford Historic Document Center by Stanwood Morss.

Described by Arthur Wilmarth as "Marshall Whittier's meadow," this photograph looks back to the Pearl-Webster house on the left and the Wilmarth-Morss house on the right.

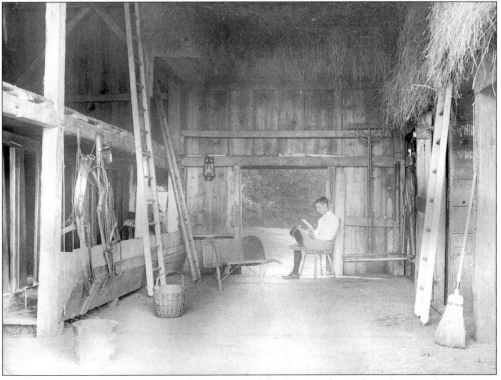

This carefully posed picture shows the interior of the barn at the Wilmarth-Morss house.

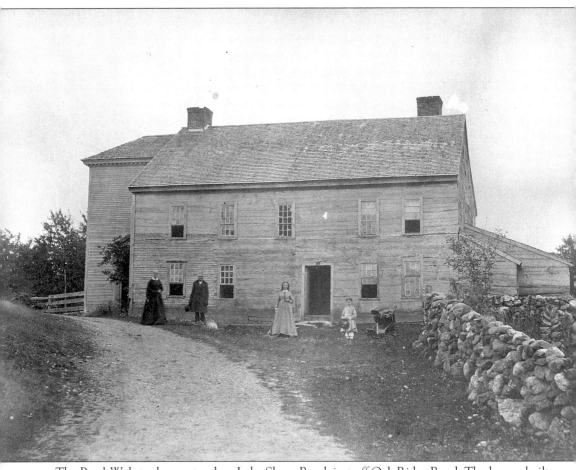

The Pearl-Webster house stood on Lake Shore Road, just off Oak Ridge Road. The house, built c. 1704, came into possession of the Pearl family in 1738. The addition on the left was a salvaged "porch" or staircase from the Second Church. When the second meetinghouse was replaced by the current church in 1843, George Pearl moved the porch to his house.

The Pearl-Webster house, originally only a one-room building, was substantially enlarged over the years, and eventually two families lived there. By 1925, the house had been abandoned and was rapidly decaying. The Boston Museum of Fine Arts bought the house, which was then carefully dismantled and partially re-created at the museum.

One side of the Pearl-Webster house was owned by James and Ruth Pearl Webster, shown here in the house with their son, George Pearl Webster. George was a gifted orator and represented Boxford in the Massachusetts General Court from 1911 until his death in 1923. He was a leader of the short-lived Progressive Party in Massachusetts and was viewed as a reformer and friend of labor.

The Runnels-Lund house, which stood on Oak Ridge Road, burned in 1926. Enos Runnels built the house in 1799 using some of the old wood and paneling from an earlier house on the same site. The last person to live in the house was Matilda "Tillie" Lund. As an elderly lady, she transferred her property to the town for the town forest in West Boxford.

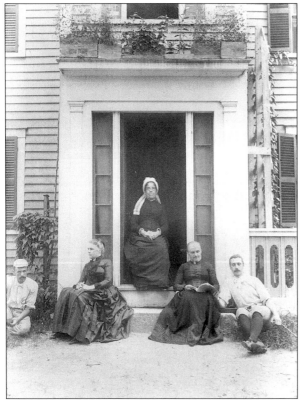

Capt. Stephen Runnels, son of Enos Runnels, was a merchant in Hawaii from 1825 until 1856. His children were sent home to West Boxford to be educated by his sisters. In this photograph, some of Stephen's nieces and grandchildren are sitting on the steps of the Runnels-Lund house. The group includes, from left to right, Phil Wilmarth, Abbie Blanchard, Mrs. H., Matilda Lund, and Arthur Wilmarth (holding the shutter bulb).

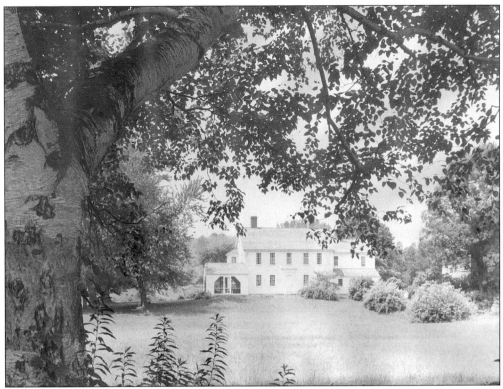

The clubhouse at Far Corners Golf Course was a residence built in 1830 by John Day, a deacon of the Second Church between 1814 and 1848. This photograph shows the house as it was restored by Merton Barrows, who lived there between 1955 and 1966. The property was later developed into a golf course.

This Arthur Wilmarth photograph shows Hovey's Pond from Lake Shore Road. Over the years, the pond has also been known as Rush Pond and Mitchell's Pond.

This picture of the Chadwick farm at 665 Main Street was taken c. 1905. Deacon Joshua Tyler Day built the house c. 1855; the porch and addition were added later. Standing in front of the house are, from left to right, John Tyler Chadwick, Everett Harrison Chadwick, James Warren Chadwick, and M. Adelaide Carver.

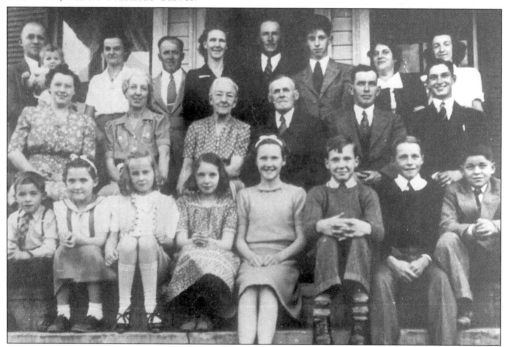

Chadwicks have been living and farming in West Boxford since John Chadwick arrived around 1688. In 1954, John Tyler Chadwick and his four sons were honored by being named Essex County's "Farm Family of the Year." This 1941 picture includes, from left to right, the following Chadwick family members: (front row) Roger, Judy, Connie, Joan, Pat, Ken, "Red" (Warren), and Jerry; (middle row) Ruth Chadwick Morin, Florence Poor, Bessie, John, John Jr., and John III; (back row) David Morin, Davida Morin, Helen Conant Chadwick, Warren, Barbara Picard Chadwick, Everett, Joel, Ida Corbin Chadwick, and Dorothy MacGregor Chadwick.

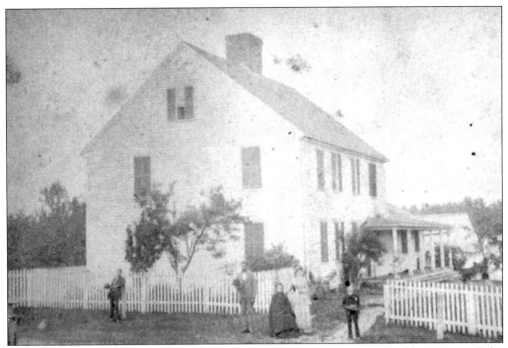

The Bradstreet Tyler house at 715 Main Street was built *c.* 1760 and was sold to Deacon Tyler in 1791. Four generations of the Austin family lived in the house after the marriage of George Austin to Charlotte Tyler Pearl. Austin organized the West Boxford Grange in 1887 and was responsible for setting out many trees along the roads of his farm.

This Wilmarth photograph shows Main Street where it passes near Sperry's Pond. In the distance, the buildings of the Barker Free School are visible. The pond has also been called Chadwick's Pond and Fowler's Pond, depending on what family lived nearby.

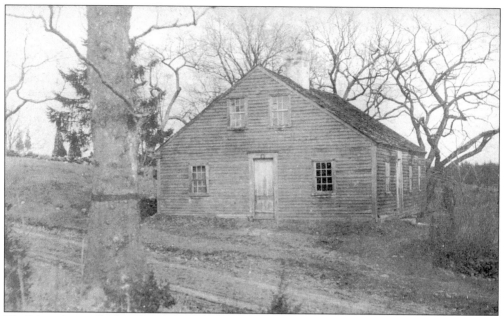

The Morse house, built in 1799, stood on Washington Street near the intersection with Willow Road. A marker notes the birthplace of nine cousins from the Morse and Parker families who fought in the Civil War. Boxford bought the house for $300 in 1914 and rented it, but eventually the house fell into such disrepair that it was torn down in 1961.

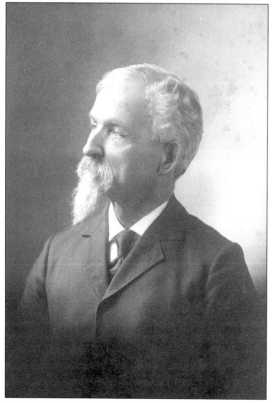

Gardner Morse, one of the nine cousins who served in the Civil War, returned to West Boxford after the war. He managed the store in the village from 1888 until 1902 and also served as a state representative in 1893. When Schoolhouse No. 4 was moved to a new lot on Washington Street in 1912, it was decided to name the new school building the Gardner Morse School.

The house at 51 Washington Street was probably built during the second half of the 18th century. The property was part of the 67 acres laid out to Thomas Leaver in 1666. In 1717, it was sold to a descendant of Thomas Cole, who came to New England in 1633 on the ship *Mary and John*. The homestead passed through generations of Coles before it was sold in 1878. Purchased just two days before it was scheduled to be demolished in 1977, it was renovated by Lance and Brenda Stickney. (Courtesy of Brenda Stickney.)

This 1913 photograph was taken from Rocky Hill on Ingaldsby Farm, looking down on the back of the Hale house. In the distance, the water tanks are visible on the hill behind the house. Johnson's Pond and Spofford Hill can also be seen. (Courtesy of the Gordon Price family.)

The Hale house, located at 18 Washington Street, was built in 1889 as a country estate for Benjamin P. Hale, owner of the Groveland mills. Walter R. Ingalls bought the house for $10,000 as a summer residence in 1912, but later moved here permanently. In 1971, Ella Ingalls became the first woman in Boxford to receive the Boston Post Cane. The house remained in the Ingalls family until 1977.

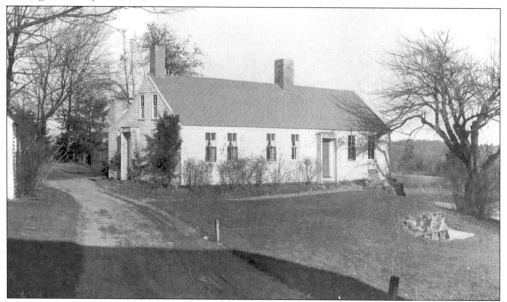

The Knowlton house is set back from Washington Street at Ingaldsby Farm. The house, which was probably built c. 1729, was the birthplace of Col. Thomas Knowlton, who was one of George Washington's officers. Knowlton died at the battle of Harlem Heights. The lines of the Knowlton house were used by Ingalls when he designed the library building in West Boxford, now the Boxford Historic Document Center.

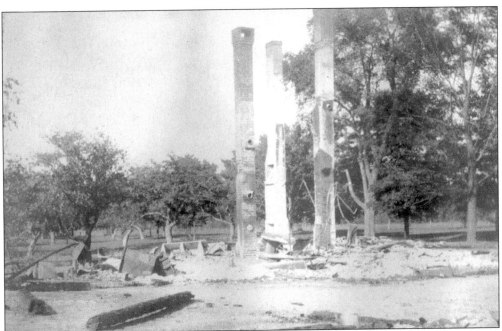

In his book *The History of Boxford*, Sidney Perley used the Isaac C. Day farm as an illustration of one of Boxford's well-managed farms. Located at 15 Washington Street, the house was built by William Ross *c.* 1835. The house was hit by lightning and burned in 1915, leaving only the chimneys standing. A new house was built on the same site.

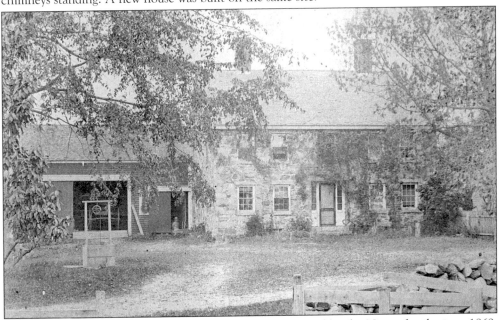

The Stone House at 276 Washington Street has been owned by the Nason family since 1869, when Phoebe Nason bought the property for $4,100, which she paid in one-dollar bills. A much older house that had been built by the Eames family stood on the site, but was torn down in 1845 and replaced with the current house. The stones for the house were taken from the south shore of Hovey's Pond. (Courtesy of Ruth Nason.)

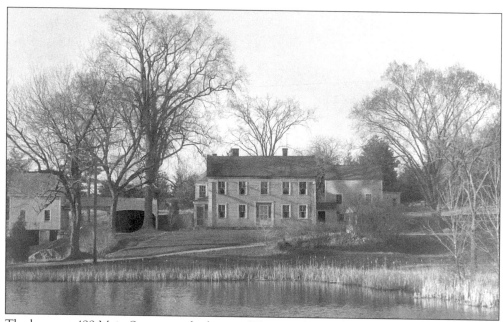

The house at 499 Main Street was the home of Harry Cole for much of the 20th century. Built in 1810, it replaced an earlier house. The history of the farm shows that it was owned by many different West Boxford families, including the Tylers, Bradstreets, Killams, Perleys, Pearls, Woods, and Coles. This photograph shows how the house looked in 1965, when the outbuildings were still standing.

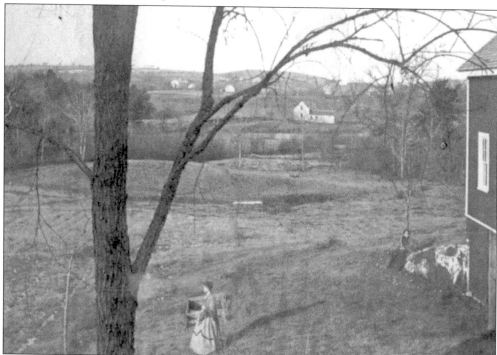

This stereopticon card shows the view from the barn at 499 Main Street, looking toward West Boxford Village. Notice how open the land was in the late 19th century.

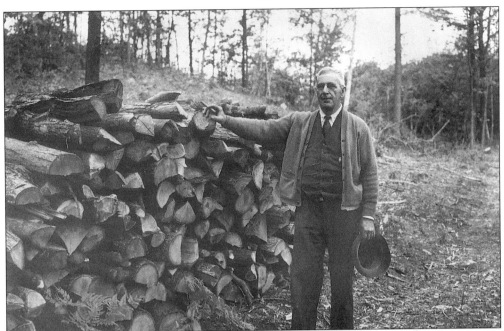

Harry Lee Cole served in public office for Boxford for 63 years, including 61 years as selectman and 50 years as the chairman. He was also an assessor, forest warden, surveyor of lumber, member of the board of health, and registrar of voters. Cole worked as a farmer and lumberman. He is shown here in 1946 in the Robert Dodge woodlot.

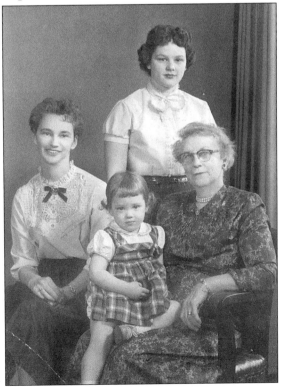

Harry Cole married Ethel Killam, a girl from the farm across the road, in 1904. Like her husband, Ethel graduated from the Barker Free School. The Cole's three daughters settled near them in West Boxford. Four generations of the Cole family are shown. They are, from left to right, Betty Cole Perkins, Rae Marie Walsh, Barbara Perkins Walsh, and Ethel Killam Cole.

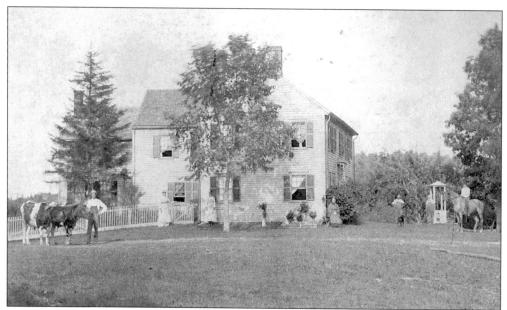

The Cole house, located at 363 Main Street, has had a storied history—a sensational murder trial in 1769, a bequest of the farm to a hired hand, and a fire that destroyed most of the house in 1945. This photograph shows the house as it appeared before 1860, when it was owned by Ephraim Foster Cole. The fire burned all but the left wing. When rebuilt, the house was reoriented to face Main Street.

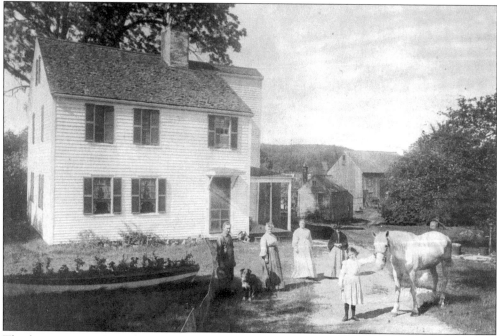

The house at 411 Ipswich Road was called Ashcroft when it was owned by the Sias family between 1872 and 1917. This c. 1905 photograph includes the family dog, horse, and a dory full of flowers. Those shown are, from left to right, John Sias, Mary E. Gerry Sias, Mary Staples Gerry, Hattie Pratt, and Martha Stratton.

Witch Hollow Farm, located at 474 Ipswich Road, is probably one of the most recognizable landmarks in Boxford. Recent studies have shown that the house was built between 1725 and 1750, although it is possible that an older house was on the same site. This late-19th-century photograph shows the house surrounded by cornfields. Bayns Hill is visible in the background, a nearly treeless pasture.

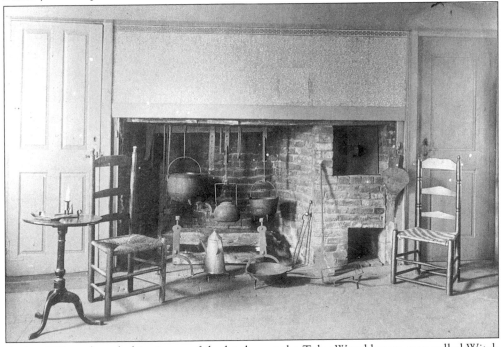

Arthur Wilmarth took this picture of the kitchen at the Tyler-Wood house, now called Witch Hollow Farm. The house was sold in 1919 to Arthur Pinkham, who began the process of restoring it. Pinkham was convinced that the house was haunted by the ghost of a young lady caught up in the Salem witch trials. Although 13 members of the Tyler family were accused of witchcraft, none lived in this house.

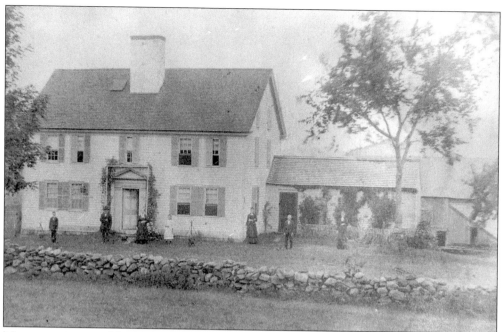

Many generations of Carletons have lived in this home at 106 Valley Road. Built in the mid-18th century, the house was sold in 1945 to Herman Young, who restored it. Given the placement of the chimney in front of the roof's peak, the house was probably a smaller saltbox that was later raised to a full two-story building.

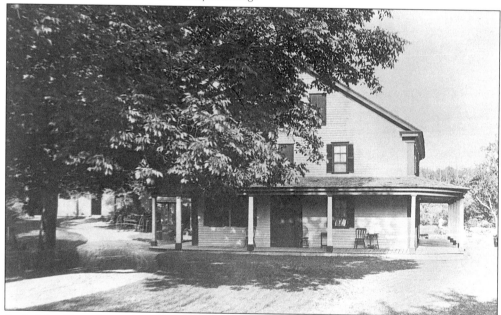

Eagle Nest Farm, located at 35 Valley Road, received its name from a large boulder near the house. The original half-house appears to have been modified with the addition of a second structure, which was moved to the old house. The farm was owned by the Kimballs and then the Fowlers for many years. Dorothy Woodbury and her family moved here in 1950 and restored the house.

This view shows the entrance to Valley Road, as photographed by Arthur Wilmarth near the end of the 19th century.

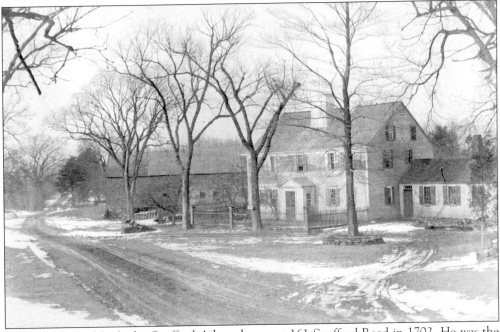

Thomas Spofford built the Spofford-Adams house at 161 Spofford Road in 1702. He was the first Spofford to settle in Boxford. The house was later owned by Isaac Adams, a captain of the militia in 1762. Adams also served as selectman for 14 years and as a representative to the Massachusetts General Court. Four of his sons fought in the American Revolution.

The Andrew house on Essex Street dates from 1788. Among the owners was Abijah Northey, a Salem merchant who decided to try living in the country and kept a detailed journal of his life in West Boxford. In 1837, the house was sold to Jonathan Andrew, the father of popular Civil War Gov. John Albion Andrew. Members of the Andrew family continued to live in the house until 1958.

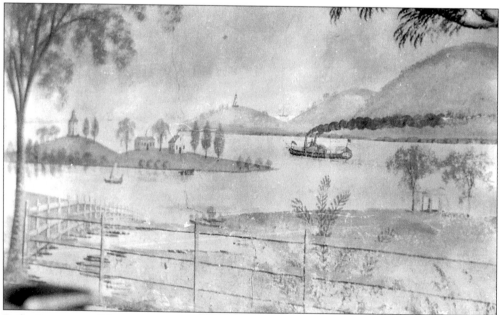

Rufus Porter, a well-known itinerant muralist, spent his childhood in West Boxford on Ipswich Road. As a young man, he traveled throughout New England painting murals and miniatures. He is known to have painted murals for three Boxford houses, but unfortunately, only the mural in the Andrew house survives. Rufus Porter was also known as the founder of the journal *Scientific American.*

Five

EDUCATION

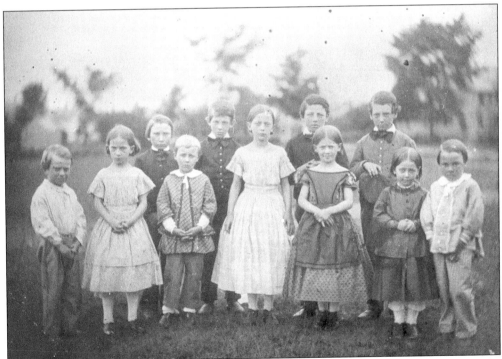

Before the 20th century, Boxford had a number of one-room schoolhouses scattered across the town. These children attended the District No. 1 schoolhouse in 1860, located on Lockwood Lane. They include, from left to right, the following: (front row) Charles Perkins, Phineas Killam, Hattie Perkins, Evie S. Sawyer, Susan M. Sawyer, and Justin Curtis; (back row) Leonidas Curtis, James B. Sawyer, Procter Perkins, and Thomas B. Sawyer.

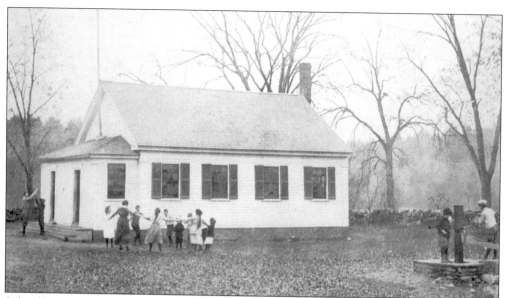

Schoolhouse No. 2, later known as the Palmer School, was located near 58 Main Street. It was built in 1845 to replace an earlier school on the same site. The town discontinued the use of the Palmer School in 1931, when the Aaron Wood School was built. Edna Rich Morse, wife of Lewis Kennedy Morse, bought the old school and had it moved to its current location in back of Cole School. It is now known as the Little Red Schoolhouse. It was listed on the National Register of Historic Places in 1998.

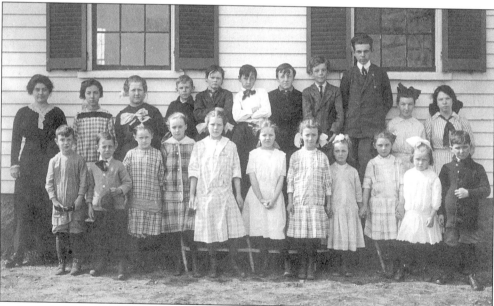

In the early 20th century, Boxford teachers taught children ranging in age from 5 to 15. These students attended the Palmer School in 1914. They are, from left to right, as follows: (front row) Archer French, Freddie Sammah, Laurinda Parkhurst, Mildred Parkhurst, Blanche Brown, Alice Gillis, Beatrice Oughtibridge, Alice Cheney, Helen Gillis, and Milton Ricker; (back row) teacher Mildred Hilyard, Gladys Moore, Grace Brown, Howard Butler, Gardner Starrett, Malcolm Gillis, Arthur Phillips, Horace Moore, Lester Cranston, Barbara Perley, and Ethel Noyes.

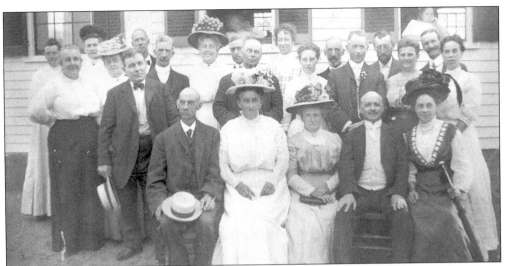

Pride in the local school districts resulted in some elaborate reunions. This reunion for District No. 2 took place in the early 1900s. Those attending include, from left to right, the following: (first row) William Conant, Lucy Perley, Carrie Bruce, Elmer Conant, and Emma Poole; (second row) Charles Bixby, Julius Atherton, Alice Gage, Maurice Woods, Lillian Killam, and Lizzie Butterfield; (third row) Louise Perley, Lucy Parkhurst, John W. Parkhurst, Edith Green, Timothy Woods, Sadie Matthews, Frank Parkhurst, Hiram Towne, and George Parkhurst; (fourth row) Agnes Moore, Annie Mortimer, and Jack Kaler.

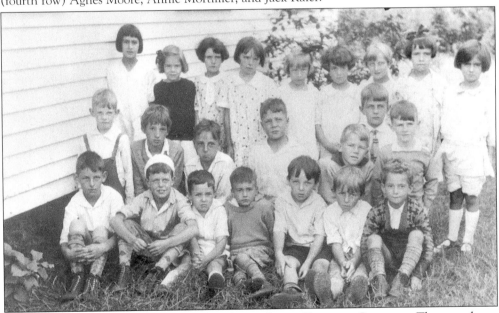

Schoolhouse No. 3 was located on Ipswich Road near Harmony Cemetery. These students, grades one through four, attended in 1930. They are, from left to right, as follows: (front row) John Hills, Ernest Tansey, Ralph Von Kamecke, Franklin Killam, George Arthur Gould, Raymond Gamble, and Sidney Gurley; (middle row) Arthur Rollins, Arthur Gurley, Frank Crawford, Donald MacPherson, Robert Little, Robert Parkhurst, and Tommy Butler; (back row) Martha Mortimer, Betty Little, Helen Tansey, Katherine Gamble, Natalie Walsh, Kathryn Peabody, Virginia Taylor, Margaret Killam, and Florence Mello.

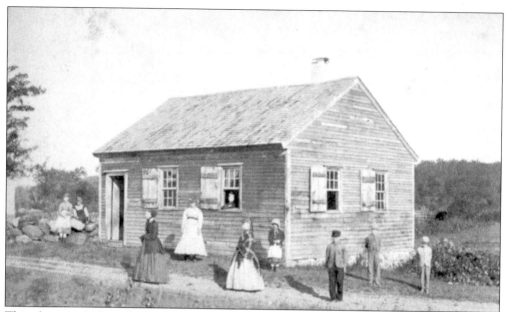

This photograph dates from 1869, shortly before Schoolhouse No. 5 was replaced. Located at the corner of Ipswich Road and Valley Road, there were actually three different school buildings here. This school, the second on the site, was built in 1797. It was known as the Old Red Schoolhouse, and its location is marked with a stone tablet.

A new school for District No. 5 was built in 1882 on the opposite side of the road. In 1914, this school was named the Lucy Kimball School. It was discontinued in 1931 and moved to Washington Street in West Boxford, where it was converted into a tearoom known as the Gray Goose. The building burned the following year.

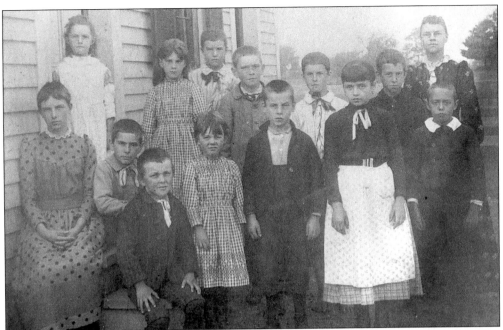

These students attended Schoolhouse No. 5 in 1892, with Marion Pearson as the teacher. The girls are in their best dresses for the picture. Those shown, from left to right, are as follows: (front row) Mary Whitney, Harry Cole, Dana Killam, Ethel Killam, Victor Salois, Delia Salois, and Chester Whitney; (back row) Ervette Sias, Florence Killam, Wilber Sias, William Cole, Winnie Sias, Oliver Killam, and Marion Pearson.

After its days as a school, the Old Red Schoolhouse was moved several times. Back then, small buildings were easily moved, and the cost was less expensive than building a new structure. The school was first moved to a spot near 190 Main Street and then to Frye's Corner in East Boxford. In this photograph, it is in its final resting place at 125 Georgetown Road. It was burned by the fire department in 1987.

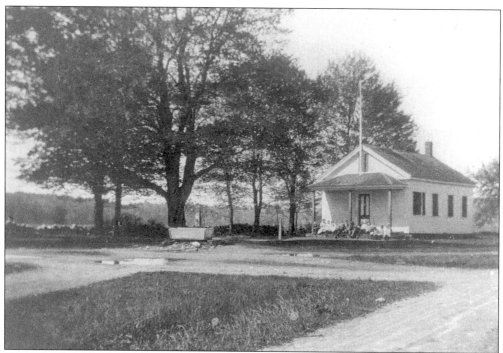

Schoolhouse No. 6 was located in West Boxford at the intersection of Lake Shore Road and Main Street. It was called the Mary Tyler Day School, as Mary Day bought the land for the school and provided the granite foundation. The school, shown in 1915, was in use between 1834 and 1931.

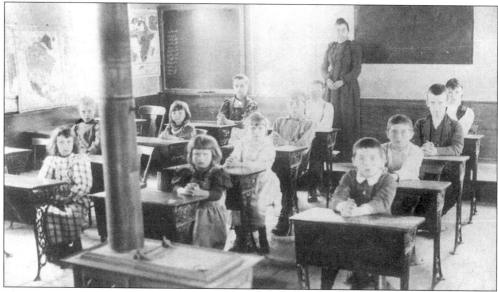

The interior of Schoolhouse No. 6 was modified in 1880, when the old benches were removed and modern desks were installed. These 1894–95 students include, from front to back, the following: (left row) Eahne Reynolds, Bess Whittier, unidentified, Lillian Wright; (middle row) Sadie Rea, Evelyn Pearl, George Pearl, Frank Chadwick, teacher M.A. Pearl; (right row) Willard Pearl, Howard Pearl, Clarence Reynolds, and Lois Reynolds.

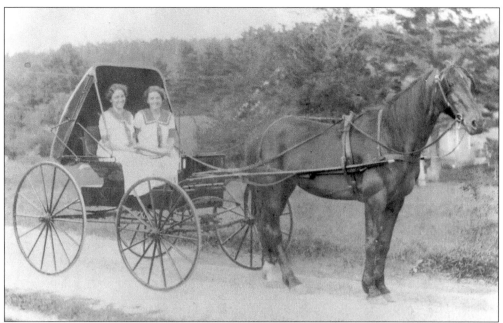

Frances and May Spofford, twins from Melrose, taught in West Boxford between 1911 and 1913. Frances taught at Schoolhouse No. 5 and boarded with the Sias and Lyon families. May taught at Schoolhouse No. 6 and lived with the Austins. The twins were married on October 7, 1914, in a double ceremony.

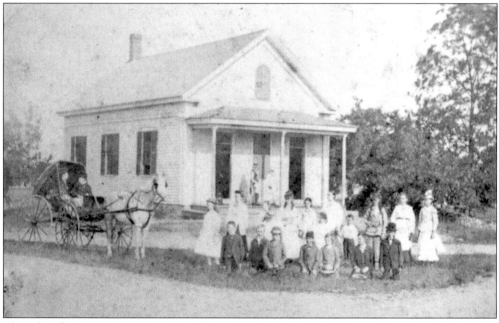

The schoolhouse in District No. 4 (called District No. 7 between 1840 and 1869) stood at the corner of Main Street and Washington Street in West Boxford Village. In the summer of 1912, the school was moved down Washington Street to a new lot and was converted into a two-room schoolhouse. It was later named the Gardner Morse School. Lincoln Hall was built on the old site next to the store.

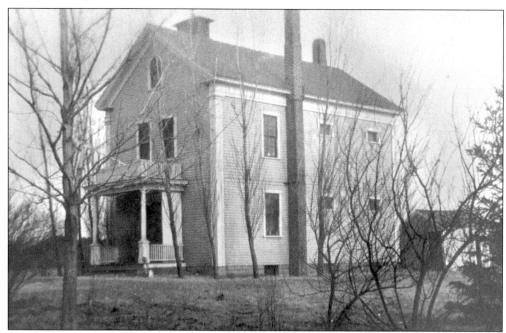

The "new" Gardner Morse School consisted of the old one-room schoolhouse as the second floor, with a new first floor underneath. It was considered modern, with a cellar, furnace, and running water, although the outhouse was still used for years later. The school was divided so that the children in grades one through four studied on the first floor, while older students in grades five through eight were on the second floor.

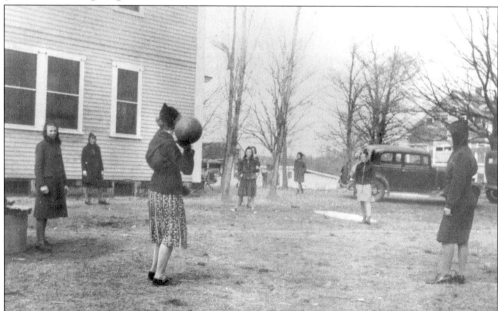

This photograph shows a physical education class at the Gardner Morse School in the 1930s. Among the girls playing are Phyllis Gager, June Sperry, Ruth Whittier, and Miriam Weatherbee. The girls played on one side of the school and the boys on the other. Across Washington Street, Paisley's farmstand is visible.

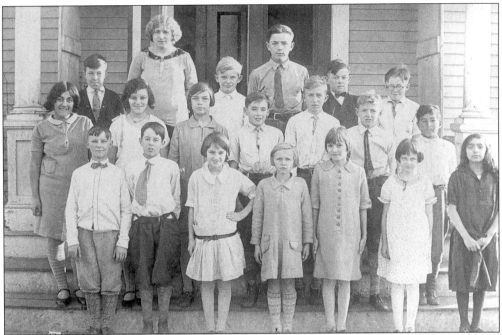

This picture, taken on November 27, 1928, shows the students in grades five through eight at the Gardner Morse School. Shown, from left to right, are the following: (front row) Joseph Budnick, John Benson, Elizabeth Cole, Helen Colby, Marion Lyon, Mary Greenler, and Grace Pellereti; (middle row) Mary Kachanian, Juliette Auger, Shirley Pearl, Gordon Andrew, Ernest Colby, Joseph Colby, and John Kachanian; (back row) Arthur MacGregor, Miss Corbett, Albert Frost, George Lambert, Joseph Lambert, and Charles Andrew.

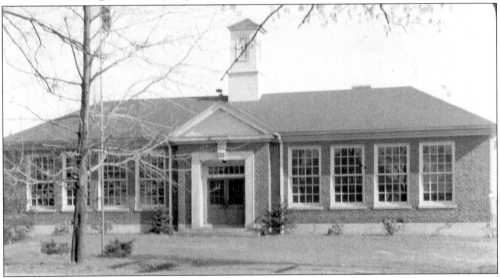

For years, the superintendents complained about the condition of the Gardner Morse School. The 1939 school annual report stated, "The school must be replaced as soon as possible [and] the building, generally, is in such poor repair that no reconditioning program is practical." Finally in 1941, the new Gardner Morse School, shown here, was completed. Since 1972, it has been used as the West Boxford library.

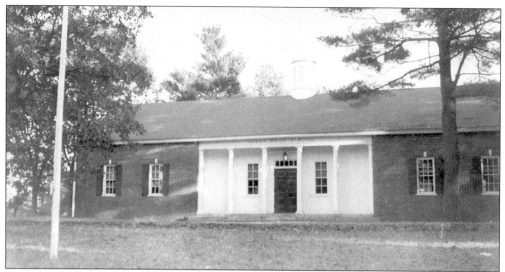

In East Boxford, a similar consolidation process occurred. The Aaron Wood School, also brick and with two rooms, was completed in 1931. The old one-room schoolhouses were sold off at auction, and all children in East Boxford came to the new school. As the population of Boxford increased rapidly during the 1950s, the Aaron Wood School became obsolete and was replaced by the Harry Lee Cole School.

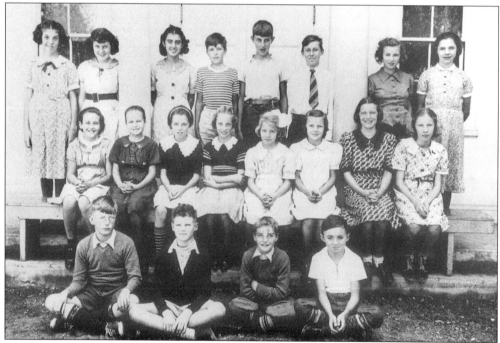

Aaron Wood students in grades five through eight pose in this c. 1938 photograph. The students include, from left to right, the following: (front row) Lewis Haynes, Harold Klock, Henry Titus, and Edward Millen; (middle row) Sally Waters, Mary Lou Waters, Ruth Gamble, Nancy Bowen, Joan Walsh, Barbara Curtis, Jean MacPherson, and Natalie Walsh; (back row) Kathryn Peabody, Helen Tansey, Florence Mello, Alden Wadleigh, Robert Parkhurst, Lester Abbott, Barbara Millen, and Shirley Towers.

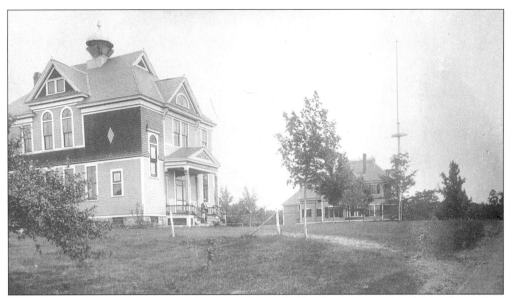

The Barker Free School was established in 1883, funded by the estate of Jonathan Tyler Barker. Situated on Main Street just north of the West Boxford Village, the school included a large academy building on the left and the principal's house. Open to all West Boxford students who passed a qualifying exam, the school also took paying students from neighboring towns. It closed in 1919, and the academy building (left) was later torn down.

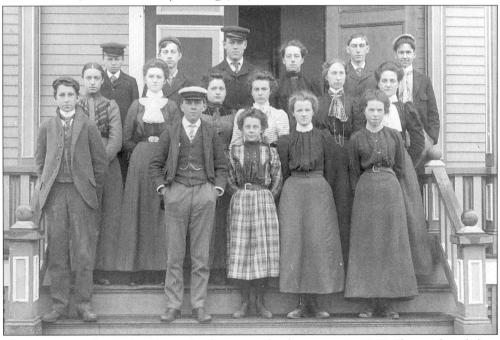

The students at the Barker Free School pose on the front steps in 1900. Shown, from left to right, are the following: (front row) Frank Spofford, Dana Killam, Ethel Killam, Mary Barker, and Maggie Doherty; (middle row) Addie Foster, Ervette Sias, Bernice Moxley, Elvira Day, Ethel Harriman, and Elizabeth Doherty; (back row) Nat Gage, Frank Harriman, James Nason, Katherine Perley, Harry Cole, and Roy Pearl.

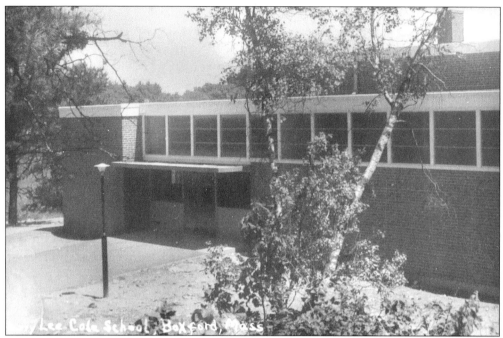

The Harry Lee Cole School opened in 1954 for students in East Boxford with an auditorium and four classrooms. That year, 96 children went to Cole, 33 stayed at Aaron Wood, and 47 were at Gardner Morse in West Boxford. By 1961, seven additional classrooms had been built at Cole School, and the enrollment reached 342 students.

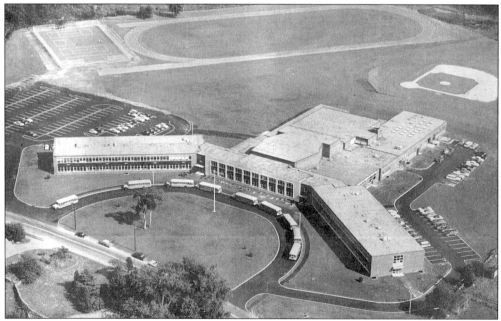

Masconomet Regional High School opened in 1959 with 767 students. Boxford had been sending its high school students to other towns for years, but given the postwar surge in population, they could no longer find schools willing to take them. Town officials eagerly joined with Topsfield and Middleton in 1956 to create the regional school district to solve the problem.

Six
BUSINESS AND INDUSTRY

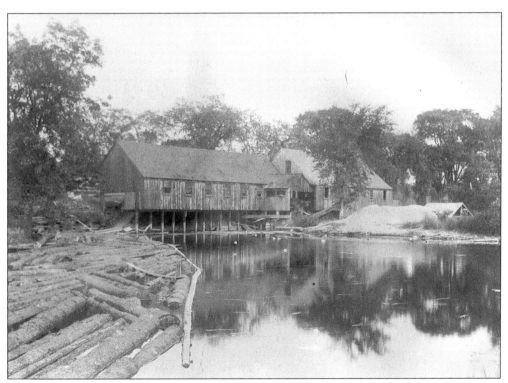

John Hale built a dam on Lowe's Pond c. 1765 and a sawmill by 1770. There have been many owners of the mill since Hale, including several members of the Lowe family, Israel Herrick, and Chaplin and Tidd. Charles Chaplin ran the mill until 1960, one year before his death at age 94. Charlie Killam built a new mill nearby in 1965 and restored the little mill office on Depot Road.

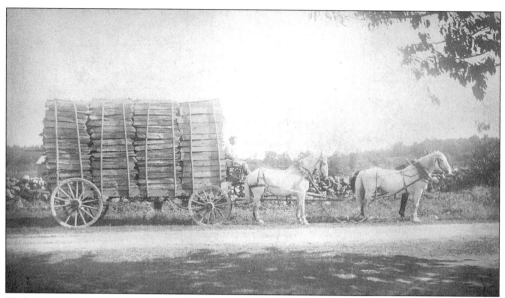

Walter French is pictured here with a load of wood from Solomon Howe's sawmill on Howe's Pond, off Mill Road. The site, which dates from 1710, included a sawmill, gristmill, knife forge, sawdust house, and icehouses. French was employed by Solomon Howe for many years.

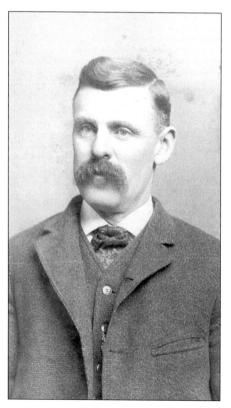

Solomon Howe owned the mill complex between 1872 and 1913, having bought it from Augustus Hayward. Howe used the sawmill primarily for cutting timbers for the Essex shipyards. The Howes did not live near the mill, but instead resided at 20 Topsfield Road. The house is pictured on page 20.

The mill complex was surveyed and photographed as part of the Historic American Buildings Survey in the early 1930s. By 1938, the gristmill was no longer active, and the surrounding buildings were falling down. Charles Chaplin bought this mill complex in 1913 and owned it until his death in 1961. He only ran the gristmill on special occasions, although he used the sawmill until the 1950s.

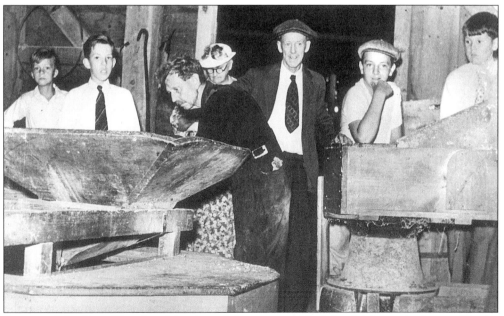

As part of the First Church celebration of the centennial of the third meetinghouse, Charles Chaplin ran the gristmill in 1938. Watching the demonstration are, from left to right, Perley Rea, Warren Rea, Charlie Chaplin, Lucy Peabody, Raymond Perley, George Gould, and Edward Haynes.

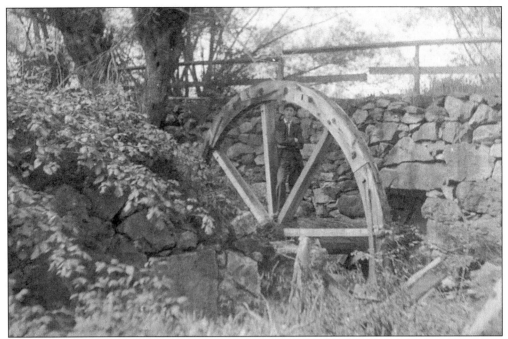

This is the old waterwheel associated with the mill on Hasseltine (Porter) Brook in West Boxford. Capt. Jonathan Porter erected a dam across Brook Road sometime in the late 1830s to create a millpond from the brook. He already had a building on the site that was first used as a carpenter shop and then as a sawmill. Later, the property also included a gristmill. The mill continued to be used until about 1875.

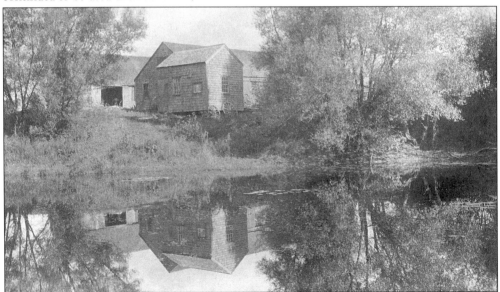

The mill building near Brook Road was later owned by John Horace Nason and Daniel F. Harriman. Nason came from North Andover to sharpen tools for the miners in the 1864 silver mine craze. Nothing came of the mines, but Horace Nason decided to stay in West Boxford anyway. This photograph shows the property with Nason's wheelwright shop. The building burned in 1894.

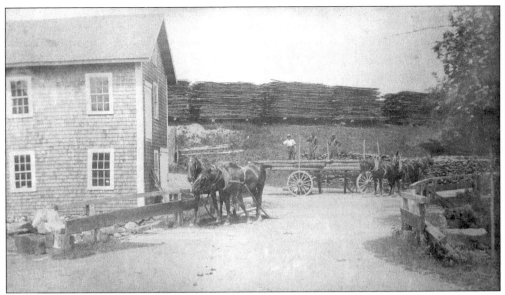

Job Frame's sawmill was located on Fish Brook near Lockwood Lane. It is thought that this is the same site as the Symonds sawmill, which was built prior to 1700. By 1800, a gristmill had also been built. Dean and Daniel Andrews bought the mill from Capt. Joseph Symonds *c.* 1850. It was later sold to Job and George Frame, who used it until 1898. The mill was later destroyed by fire.

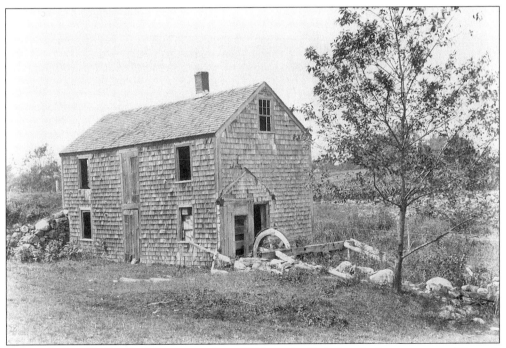

Deacon Joshua T. Day built his gristmill in 1844 on the little brook that runs out of Hovey's Pond near Main Street in West Boxford. Although author Sidney Perley states that the mill was still operable in 1880, it is clear from this Arthur Wilmarth photograph that the mill was rather dilapidated by the 1890s.

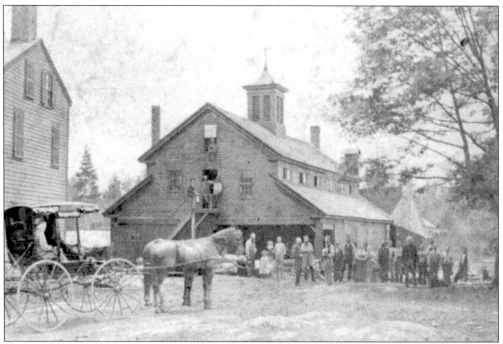

In 1866, Byam and Carlton built their match factory on a former industrial site on Lawrence Road in East Boxford. Fish Brook had been dammed up to create a millpond, and mills flourished here as early as 1795. At its peak, the match factory produced 5 million wooden matchsticks a day, which were then shipped into Boston to be dipped and packaged.

The Diamond Match Company bought out Byam and Carlton in 1880 and ran the factory for another ten years. Gradually, the supply of pine wood diminished enough so that it was no longer profitable to run the match factory. The building was used as a sawmill for a few years. One night in 1905, the flume went out, draining the pond, as seen in this photograph.

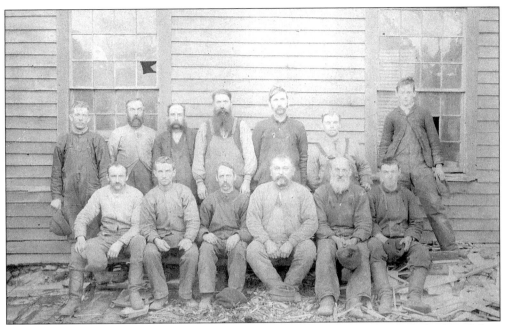

This *c*. 1890 photograph shows some of the match factory workers. They include, from left to right, the following: (front row) Washington Pickard, Thomas Twisden, Caleb Mortimer, Joseph Fiske, Rufus Emerson, and Willard Emerson; (back row) Daniel Howe, George Foster, Samuel Frye, James A. Elliott, Samuel Peabody, Julius Atherton, and Eugene Newhall.

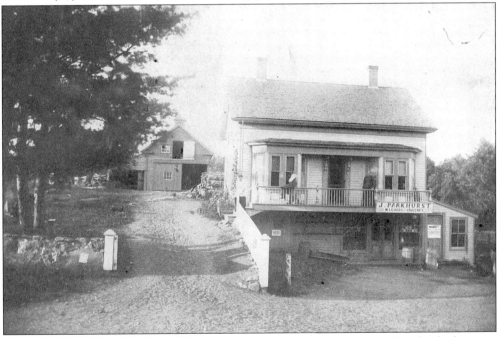

John Parkhurst, superintendent of the Byam and Carleton Match Factory, bought the house at the corner of Main Street and Lawrence Road in 1876. He opened a store in the basement for the convenience of the match factory workers. Parkhurst and his wife moved into the house in 1887, and he continued the store until the match factory closed.

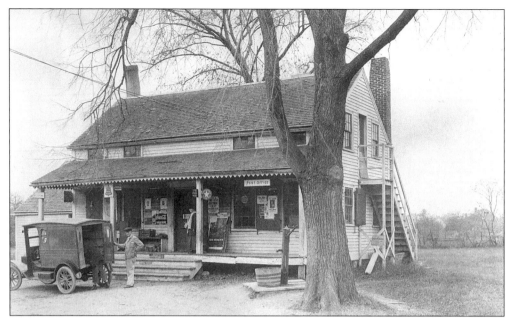

The store in East Boxford Village was constructed in 1834 as a carpenter shop on Topsfield Road. The building was moved to its current location in 1839 and converted into a store. There were many storekeepers until Frederic A. Howe, who owned it for 35 years. Oliver Bixby was the storekeeper at the time of this c. 1915 photograph, which was used in the *Silent Salesman* magazine.

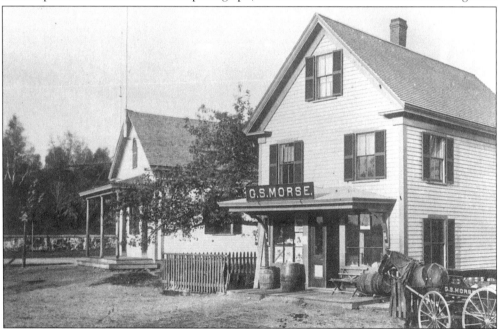

Gardner S. Morse owned the store in West Boxford between 1888 and 1902. He lived above the store with his wife, Molly Sager Morse. After Mr. Morse's death in 1902, Mrs. Morse and her sister continued to keep the store. They sold it to Leroy Colby, who was the storekeeper until his death in 1928. Schoolhouse No. 4 stood next to the store until it was moved down Washington Street in 1912.

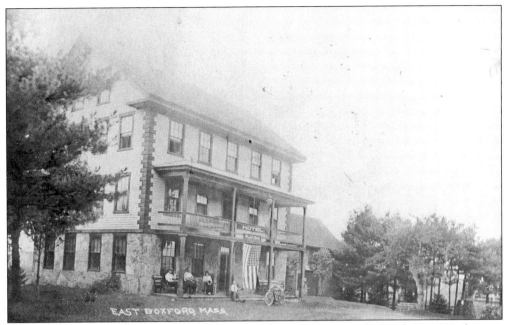

John Hale built a large shoe factory near his house at 120 Ipswich Road. In 1889, his son converted it into a summer hotel called the Hotel Placidia. Sidney Perley states that the resort was attractive and was "situated on the shores of a beautiful lake, and near cool, shady groves." Over time, unfortunately, the hotel developed an undesirable reputation. It burned in 1926.

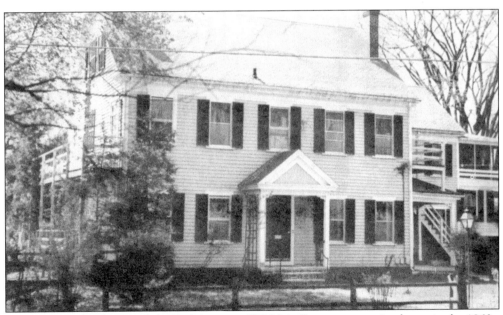

Annabelle Richardson used the Park house at 570 Main Street as a nursing home in the 1960s. She bought the house from Caroline Park, the last member of the Park family to live in the house. Caroline Park stayed with Mrs. Richardson in the nursing home until her death in 1961. Annabelle Richardson sold her home to the Hildebrand family in 1969.

Barely visible through the trees brought down by the 1938 hurricane is Benson's Ice Cream Stand. The Benson family first established a farm stand in 1917 to market produce grown on the family farm. Katherine Perley Benson branched out into ice cream in 1932 and built the addition on the front of the house. Over the years, three generations of Bensons have seen the ice-cream stand flourish.

The small shed opposite 48 Topsfield Road was used as a barbershop by Clarence Moulton between 1909 and 1914. At that time, Moulton lived across the street in the Nat Dorman house. This photograph shows him sitting outside his shop. The building partly visible on the right is Walter Osgood's harness shop.

Many Boxford men supplemented their farm income in the winter by making shoes. Little cobbler shops, often called "ten-footers," provided a place for this activity. This shop, built by George W. Chadwick in 1850, stood at the corner of Main Street and Lily Pond Road in West Boxford. It was moved to its current location behind the Holyoke-French house in 1950.

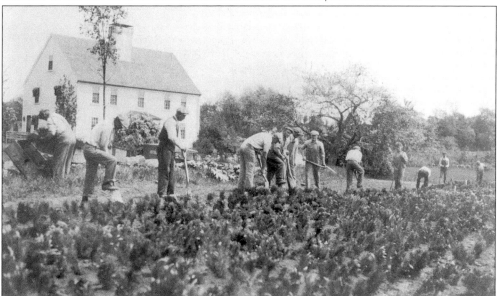

Harlan P. Kelsey bought land in Boxford for his nursery beginning in 1912, attracted by the level fields and availability of water. Other purchases followed, including the former Campground. In 1931, Kelsey moved his offices and headquarters from Salem to Boxford. This photograph shows men planting nursery stock in the field across from Kelsey's house at 20 Kelsey Road.

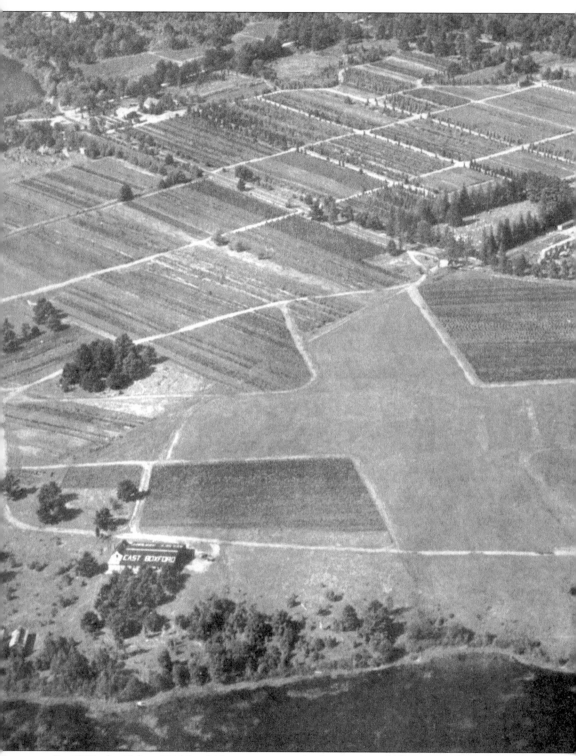

By 1932, the Kelsey-Highland Nursery consisted of more than 500 acres in the area bordered by Georgetown Road and Pond Street, on both sides of Ipswich Road. The nursery was carefully

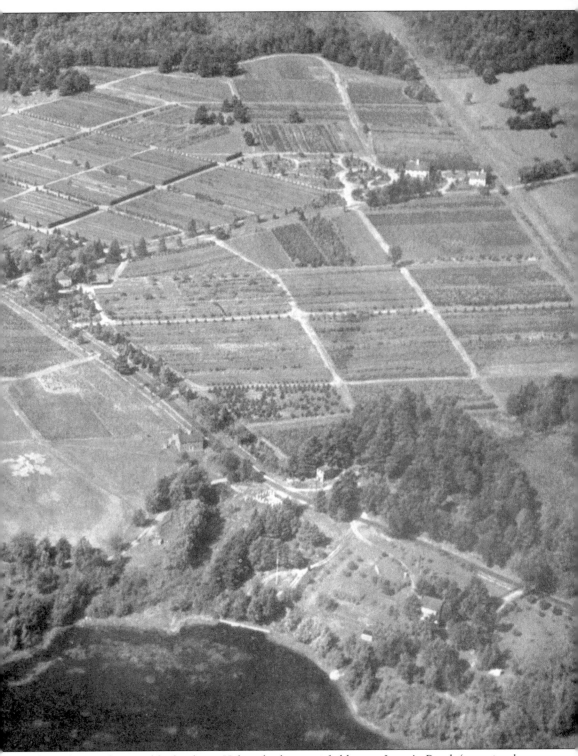

planted according to block plans. Kelsey built an airfield near Lowe's Pond (seen in the foreground) so that his wealthy customers could fly in to see his stock.

Harlan Kelsey converted the barn on his property at 20 Kelsey Road into an office. In front he designed an arboretum that showcased the various plants he offered for sale. This photograph, looking across Kelsey Road and the nursery, shows the beginnings of the arboretum, which is now being preserved by the Horticultural Society of Boxford.

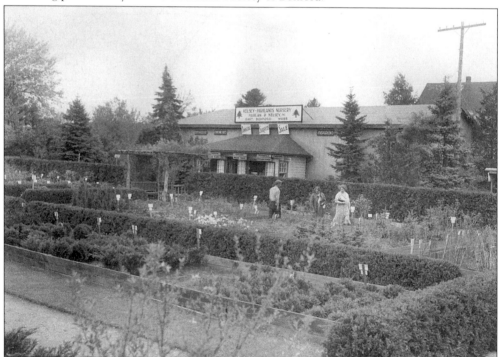

The sales shed for the nursery was eventually moved to the buildings at the corner of Georgetown Road and Ipswich Road, seen here in 1939. The sales buildings and 37 acres that remained with them were sold at auction to Dr. Simeon Locke in 1965. Dr. Locke and his wife, Jean, continued to run the nursery and the Christmas Shop until 1995, when the land was developed.

Seven

FARMING

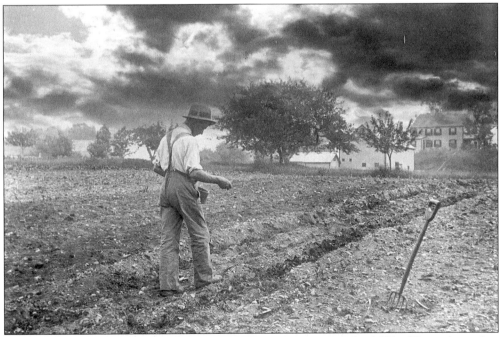

Boxford has been an agricultural community since its origins in the 1600s. The early settlers quickly cut the trees down and farmed the land. By 1846, at the peak of the town's agricultural prosperity, Boxford farmers produced 6,975 bushels of corn, 2,953 bushels of oats, 15,255 bushels of potatoes, and 1,791 tons of hay. Arthur Wilmarth took this photograph of a farmer sowing his field in West Boxford.

The 1885 agricultural census shows that Boxford had more barns (121) than houses (113). The farmers in town owned 190 horses valued at $17,270 and 47 oxen valued at $3,925. Work horses or oxen were used for the heaviest work. This team of oxen was photographed at Tillie Lund's farm in West Boxford.

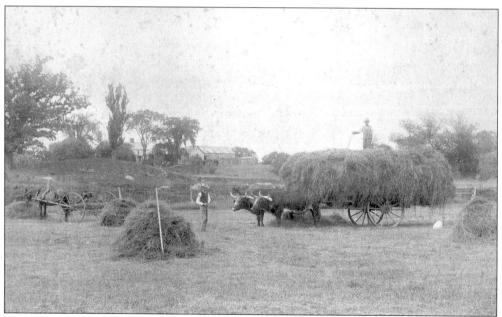

In the late 19th century, large amounts of land were either cultivated hay fields or permanent pastures. This photograph shows men haying in West Boxford, using a two-wheeled cart with a team of oxen. The load of hay was built up carefully so that it would not tip over.

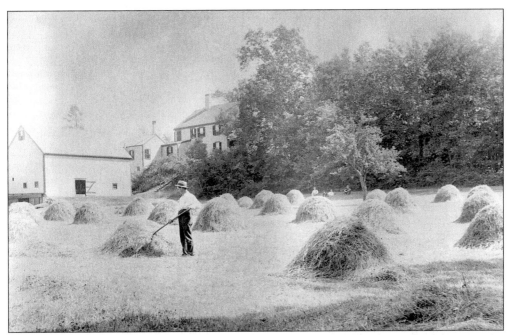

Arthur Wilmarth photographed this farmer building haycocks in the field in back of the Wilmarth house in West Boxford. A hay rake pulled by a horse would form the hay into windrows so it could dry. It was then piled into haycocks and taken to the barn for storage.

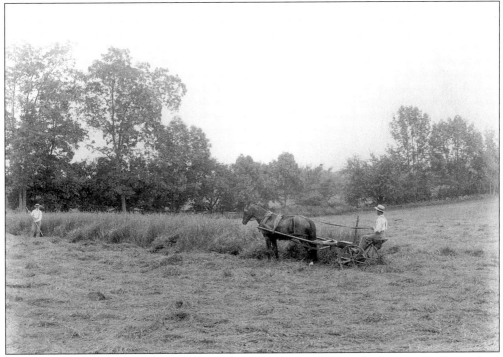

"Mike and the Mowing Machine" is the title of this Arthur Wilmarth photograph. Notice how tall the hay is compared to the other worker, who is using a bull rake to pull the mown hay from the path of the mowing machine.

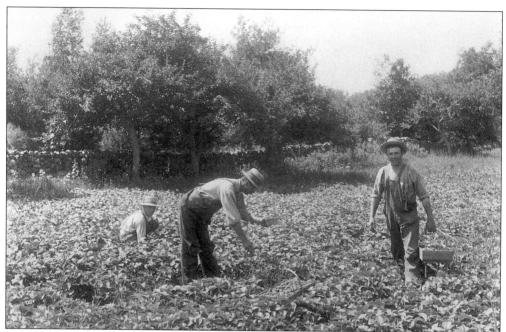

Many farmers raised strawberries in Boxford, totaling 7,005 quarts in 1885. These men are picking berries in Marshall Whittier's strawberry patch. At the time of this Wilmarth photograph, Whittier lived at 50 Lake Shore Road in West Boxford. He moved farther up Lake Shore Road in the early 1900s.

In the 20th century, a number of farmers turned to raising poultry, among them John T. Chadwick III. This photograph shows a portion of Chadwick's farm, which was located at 5 Washington Street on the Groveland line. The Chadwicks worked this farm until the death of John Chadwick in 1961.

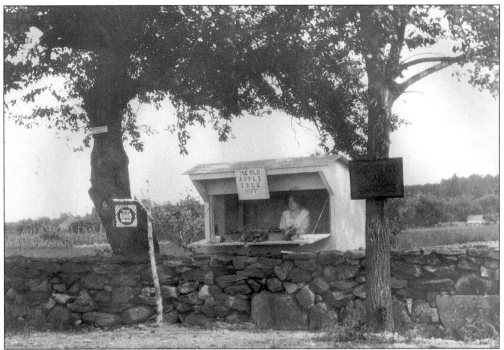

The Old Apple Tree Hut was the first stand at Ingaldsby Farm. The structure was located on Washington Street near the lane to the Knowlton house. In addition to apples, Urusula Ingalls sold eggs and Country Maid Candies, which were made by her sister, Rosamond. The candies had a picture of the Knowlton house on the box. (Courtesy of the Gordon Price family.)

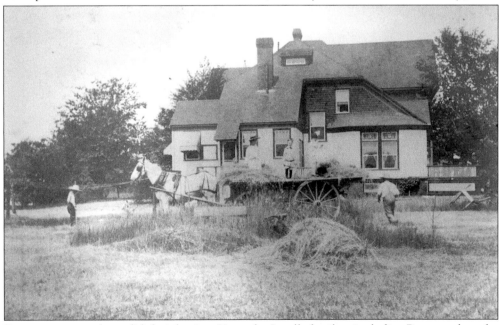

Even summer residents did their haying. Here, the Ingalls family—including Rosamond on the left, Hildegard on the wagon, and their resident farmer—work in back of the Hale house in June 1912. (Courtesy of the Gordon Price family.)

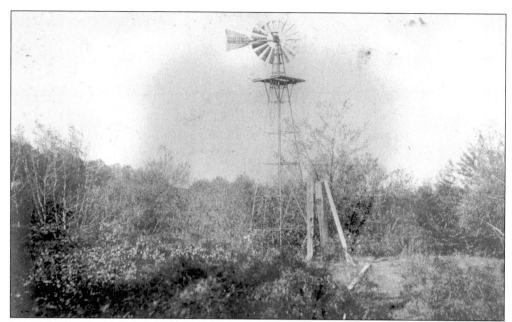

Ingaldsby Farm and the Isaac Day farm, located across Washington Street from each other, used a windmill to pump water from a spring into two water tanks atop a nearby hill. Gravity brought the water to the two houses. Shortly after this photograph was taken in 1913, the windmill was replaced by an electric pump. (Courtesy of the Gordon Price family.)

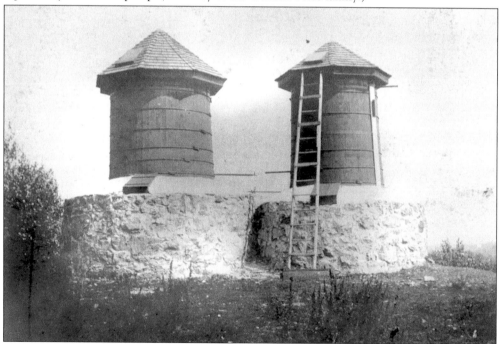

The water tanks on the hill north of Isaac Day's farm—which was owned by Allan F. Breed in 1913, when this photograph was taken—were part of the water system used by the Breeds and the Ingalls. The water towers must have been a distinctive landmark. (Courtesy of the Gordon Price family.)

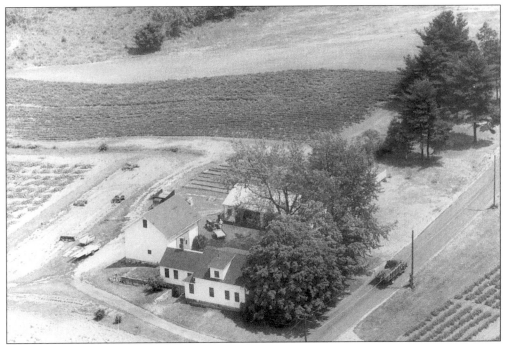

Everett and Barbara Chadwick lived at 645 Main Street at Mill Brook Farm, named for the brook and abandoned gristmill nearby. In addition to helping his father and brothers at the "Big Farm" next-door, Everett also worked on his own extensive market garden. The Chadwicks ran Mill Brook Farm from the time of their marriage in 1927 until Everett stopped farming in 1982.

Horses were an essential part of life in Boxford until they were replaced by automobiles and tractors. All households, whether farming or not, needed horses for transportation. In 1846, Boxford had 115 horses for the 940 people who lived here. By 1885, there were 190 horses for 840 people. This photograph is simply identified as "Grandpa Parkhurst's horse."

During the 20th century, tractors and trucks gradually replaced horses across Boxford. By 1936, there were only 61 horses according to the town assessors. This photograph shows the modern way that the Holgates, who lived at Woodland Farm, brought in their hay.

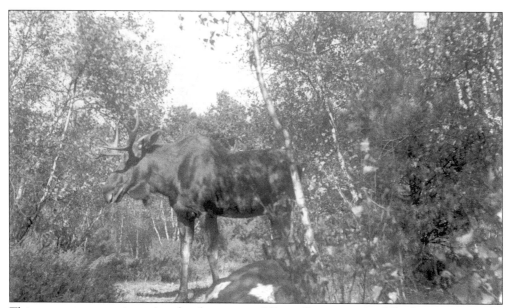

This moose was seen in various localities around Essex County in the fall of 1942. It was the first time anyone could remember seeing a moose in Boxford. Unfortunately, farmers felt that it posed a threat to their cattle, so the moose was shot by the game warden.

Eight

THE MILITARY EFFORT

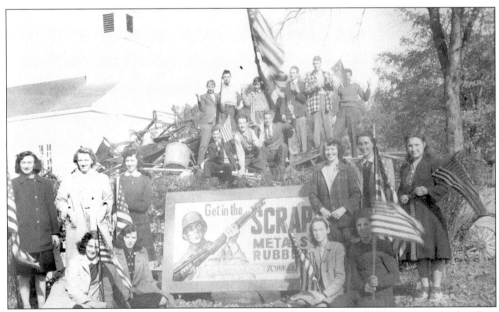

A scrap metal drive held in West Boxford in 1942 brought the children out of school to participate in this community event. Shown, from left to right, are the following: (seated in front) Ann Price, Eleanor Brown, Patricia Chadwick, and Ruby Dill; (standing in front) Marcella Lyons, Charlotte Anderson, Margaret Greenler, June Sperry, Barbara Burgson, and Edna Scranton; (seated on the scrap pile) Gordon Price, Richard Scranton, and Billie Hagan; (standing on the scrap pile) Warren Chadwick, Herbert Sperry, Edward Cunningham, Horace Hebb, Dick Adams, Dick Hopping, and Eddie Dill.

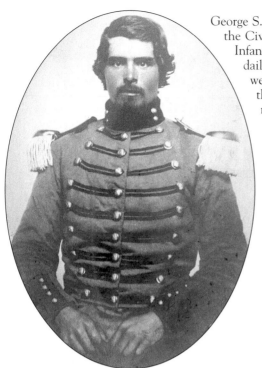

George S. Dodge was the first Boxford man to fight in the Civil War. He belonged to the Haverhill Light Infantry. Since the company had been drilling daily, they were ready to march when their orders were received on April 19, 1861. Dodge was at the first battle of Bull Run and afterwards reenlisted for three years of service. After the war, he lived in West Boxford at 86 Lake Shore Road.

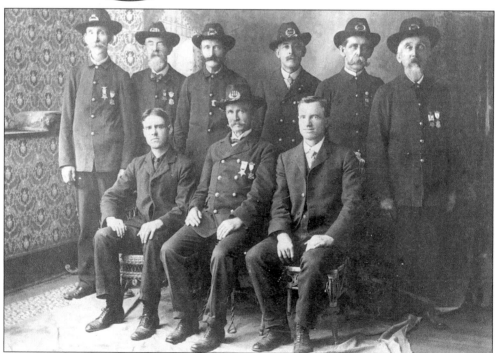

Isaac C. Day fought in a number of key Civil War battles with the 35th Regiment in 1862 and 1863. After the war, he became a member of the Groveland post of the Grand Army of the Republic (GAR) and was later elected as department commander for Massachusetts. He is seated in the middle with other GAR members. His son, Roy, is seated on the left.

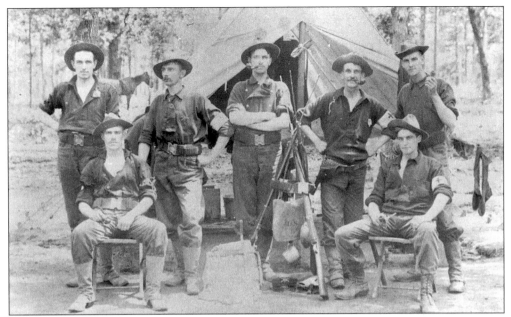

Boxford also sent men to fight in the Spanish-American War in 1898. This group, which included four West Boxford men, was at Camp Thomas in Chickamauga, Georgia. They are, from left to right, as follows: (seated) Roy M. Day and Eoford C. Fuller; (standing) Alfred K. Nason, Charles F. Austin, A.C. Harrison, W.H. Mass, and George P. Webster.

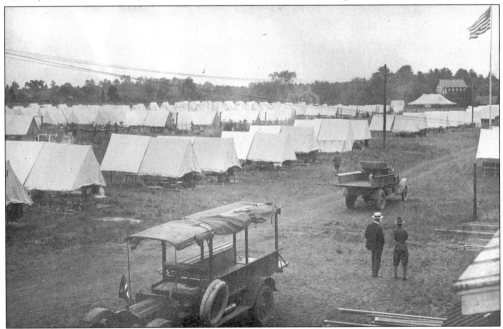

In the fall of 1862, a number of Civil War regiments trained at Camp Stanton, a temporary camp on Ipswich Road near Lowe's Pond. The Campground, as it continued to be known, was purchased by the Salem Cadet Camp Association in 1897 to be used as a summer training area for the Second Corps Cadets. This photograph also shows the Cadet House and Hotel Placidia in the distance.

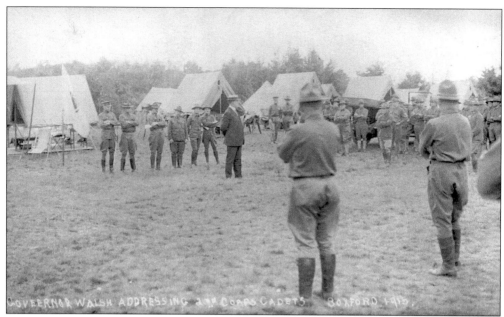

The summer training exercises of the Second Corps Cadets could be quite exciting for Boxford. Wives and families accompanied their husbands and stayed at the Hotel Placidia or the Cadet House on Ipswich Road. Meals were served by waiters in the large wooden mess hall, and nightly band concerts were held. A number of dignitaries visited the camp. Here, Gov. David Walsh addresses the cadets in 1915.

Capt. Harry Perkins of Salem spent his summers training with the cadets and eventually bought a summerhouse in Howe Village. There are many photographs of his family at the Campground. Here, the Perkins children play on a ceremonial cannon. One of the children, Joseph Perkins, continued to summer in the house at 9 Ipswich Road and eventually moved to Boxford permanently.

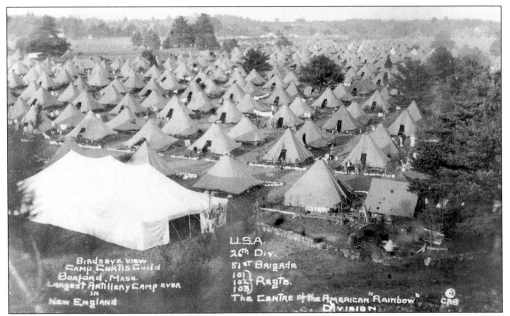

The U.S. government took over the Campground in the summer of 1917 for use as an artillery camp to train soldiers who would soon be fighting in Europe. Suddenly, some 5,000 men were camped in a Boxford field, now known as Camp Curtis Guild. Wednesday afternoons and Sundays were designated as visiting days, and thousands of families and friends came to be with the soldiers.

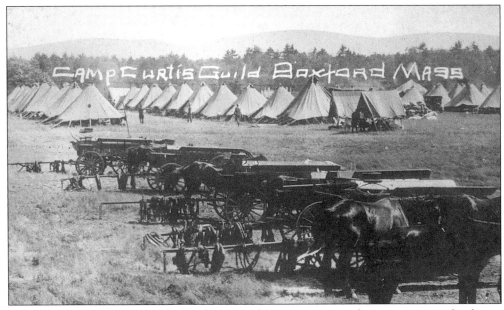

Camp Curtis Guild was named after the Massachusetts governor who was quite popular during the Spanish-American War. This postcard of the camp shows the horses and large guns. The camp was the largest artillery camp in New England.

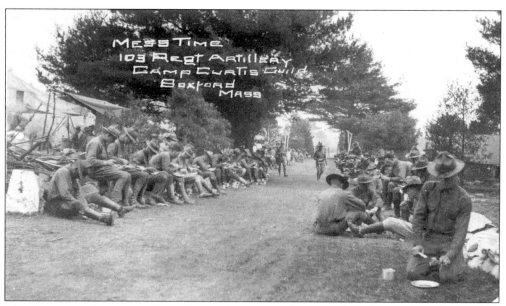

The Campground was a good site for a training camp because of the large open space, nearby water, and accessibility to the train. Supplies and provisions could be brought in and troops could be easily detached. When the orders came to leave, the troops marched to the train and traveled to New York City. Within a few days, the camp was entirely deserted.

This early-1930s Memorial Day parade in West Boxford featured a band and a number of veterans. Parades were sponsored by the West Boxford Veteran's Association between 1907 and 1934. Usually, town meeting appropriated a sum of money to be used to celebrate Memorial Day. There were frequent additional appropriations for the care of soldiers' graves and the "ancient" graves.

Nine
MUNICIPAL MATTERS

Every year, there was an article on the town meeting warrant "to take such action as may be deemed best in regard to making the roads passable when encumbered with snow." Before cars became commonplace, there was less need for roads to be plowed. Instead, they were rolled, or "pathed," and the surveyor of highways kept track of the expenses for the town. This horse-drawn plow dates from 1914.

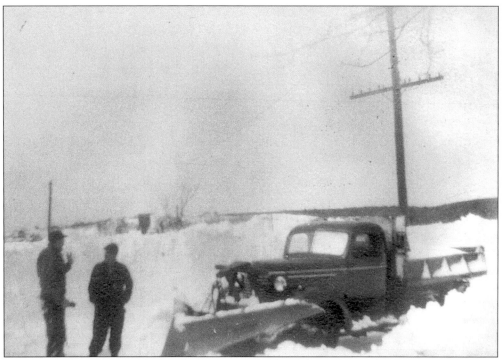

Later, snowplows were used. But plowing was difficult in the open wind-swept areas, as seen in this mid-1940s photograph taken in front of 645 Main Street. Robert Cunningham, highway surveyor for West Boxford and owner of the plow, is meeting with Dick Spofford (with camera) while assessing the results of a storm. (Courtesy of Ken Chadwick.)

Electricity came to Boxford in a piecemeal fashion. When Fran and Arthur Phillips moved to 33 Mill Road in 1945, there was no electrical service. The electric company, reluctant to put in poles for the only house on the road, finally came to verify that the Phillips really had electrical appliances. The final pole was put in place in May 1946. (Courtesy of Fran Phillips.)

116

Clayton Nelson served as the town's first police chief in 1945. He served as West Parish constable from 1941 through 1949, a time when constables were also responsible for police work. He continued as police chief from 1947 through 1949, also serving as the town's fish and game warden from 1935 to 1945. Nelson is seen here relaxing at an auction held at the Second Church.

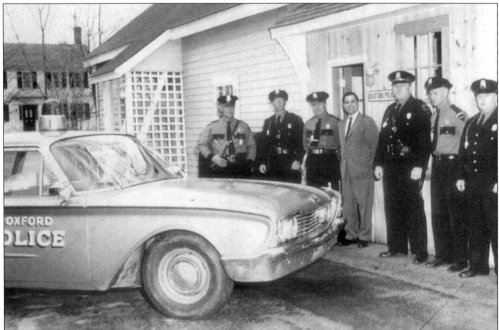

By 1961, the police department had established a new office in the building across from the East Boxford library. The department also had many more officers and a new cruiser. Shown standing in front of the police office, from left to right, are Clint French, Cecil Farnsworth, Charles Getchell, Peter Vrettos, Chief Nate Love, Earl Blake, and Walter (Herb) Gamans. (Courtesy of Dick Hopping.)

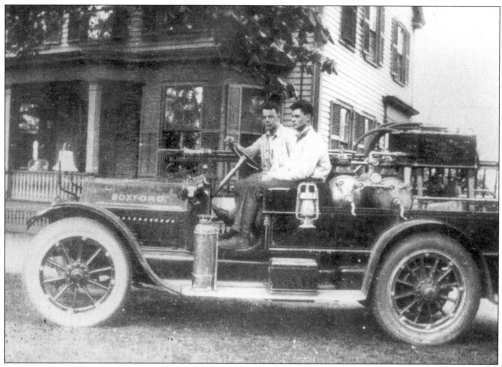

Boxford's first fire truck was a 1914 Cadillac chassis with two 40-gallon tanks. It was given to the town by Oliver Howe in 1925. The men in the truck are Clint French and Leo Richardson. There was no separate fire department at this time; fighting fires was the responsibility of the forest fire warden, who documented the cost of fighting each fire in the town report.

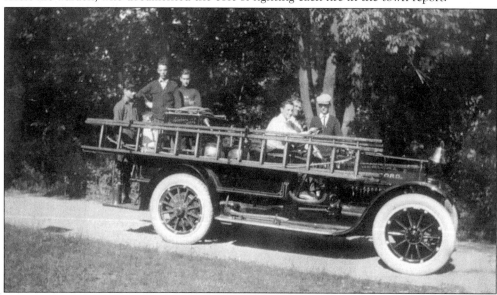

Another view of Chemical No. 1 includes, from left to right, the following: Leo Richardson, Clint French, Ernest Mortimer, Harold Gillis, Clarence Brown, Archie French, and an unidentified boy. Although house and chimney fires were fairly common in Boxford because people heated with stoves, the town was forced to rely heavily on help from other towns to fight their fires.

Boxford bought its first new fire truck in 1942, and town meeting appropriated $2,000 to erect a suitable building for it. The East Boxford fire station was located between the store and the town hall (now the community center). Eventually this building also housed the Boxford Department of Public Works and the police station. A new fire station was completed in 1983 behind the old one.

When Boxford acquired another new fire truck in 1946, the town voted to have the selectmen find proper housing for it in West Boxford. They bought the old Paradis blacksmith shop for $600. This 1969 photograph shows the old fire station with Engines No. 6 (1946), No. 3 (1964), and No. 1 (1960). The fire department burned this station in 1975 to build the new one.

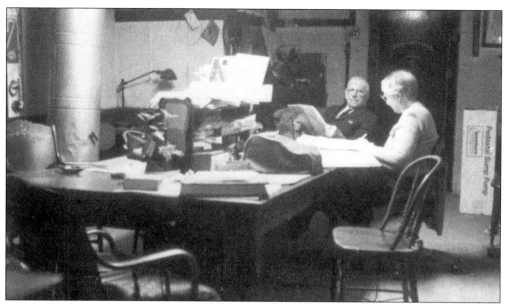

The town dedicated its newly erected town hall in September 1891. The new hall was built on the foundation of an earlier building, which had housed the Boxford Academy and Third Church in the 1820s. The town hall featured town offices, a vault, and a stage upstairs. For much of the 20th century, the main business of the town was conducted in Harry Cole's office. Cole is seen here with Barbara Perley.

It was not until the 1940s that Boxford decided it needed a town dump. Before that time, most people dumped their unusable things in a far corner of their property. The 1946 town meeting allocated $525 to purchase 40 acres of land on Spofford Road for the dump. The other proposed location was on Georgetown Road near Bootman Pond. This 1980 photograph shows Alerson Noyes sorting newspapers.

Ten

THE SOCIAL SCENE

Although a small town, Boxford had a surprising number of organizations and clubs, ranging from church-sponsored meetings to sports teams and theatrical groups. Shown are the boys of the West Boxford Baseball Club, c. 1890. In the 1930s, baseball scores were widely reported in local newspapers.

The dedication of the new flagpole on East Boxford's south common took place on August 14, 1885, during the celebration of the town's bicentennial. George W. Chadwick was the featured speaker at the ceremony. The flagpole was 85 feet high and came down during the 1938 hurricane.

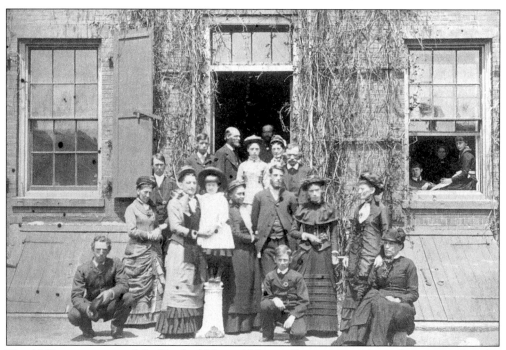

The 1881 constitution of the Boxford Natural History Society invited people interested in the study of natural history "to present to the society, books, specimens, &c, or to assist them financially." Among the members photographed at the Peabody Museum in Salem are Mr. and Mrs. William Alcott, Mary Alcott, Dr. and Mrs. Francis Stevens, Sidney Perley, Hattie Parkhurst, and John Parkhurst.

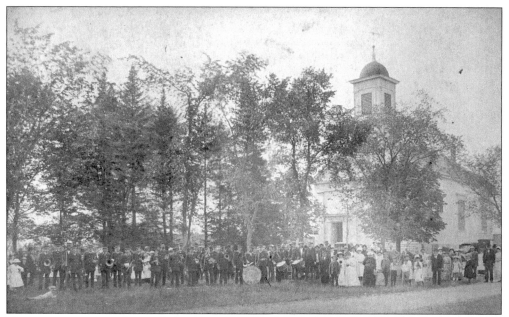

This group poses in front of the First Church during the celebration of Boxford's 200th anniversary on August 14, 1885. The ceremonies included speeches by the six clergymen who lived in Boxford along with Sidney Perley and several others. Music was furnished by the Groveland band and the Boxford choir.

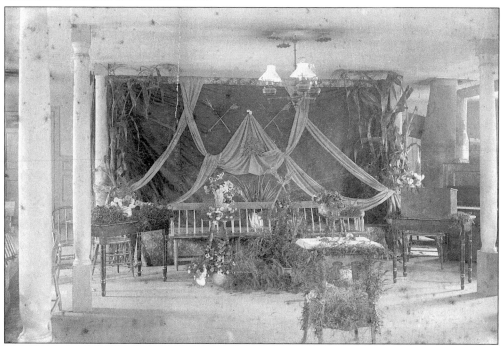

The West Boxford Grange No. 140, an organization for farmers, was started in 1887 by George W. Austin. The Grange met in the vestry of the Second Church for several years, as seen in this photograph. Later meetings were held at Columbia Hall on Washington Street and, after 1912, in Lincoln Hall. The Boxford Grange No. 298 was established in 1911. (Courtesy of Ken Chadwick.)

The Lewis Kennedy Morse playground in East Boxford was dedicated on October 31, 1930. Volunteers at a town clean-up on the following day are, from left to right, as follows: (front row, seated) Betty Ann Little, Arthur Gould, and Alice Gould; (back row) Harry Cole, unidentified, Harlan Kelsey Jr., Rev. Emerson Wolfe, Rev. Emery Bradford, unidentified, Bobby Little, Clinton Nason, Paul Killam, Arthur Gurley, James Feronetti, E. Robert Little, Raymond Perley, Melvin Gould, Charles Maynard, ? Bilodeau, unidentified, unidentified, and George Gould.

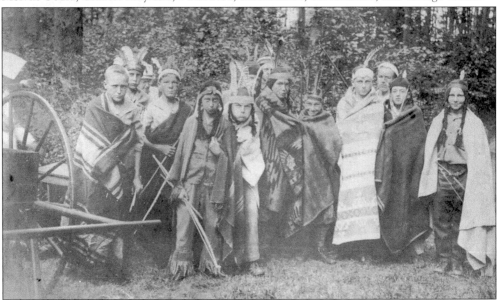

In 1930, Frank and Annette Manny and Bertha Palmer Lane wrote a pageant to commemorate the 300th anniversary of the founding of the Massachusetts Bay Colony. *Time Will Tell* was performed in the Fairy Ring with a cast of about 200. Nine historical episodes were created for an audience of nearly 500 people. Captured on film are the Native American warriors who installed a new chief in Episode 1.

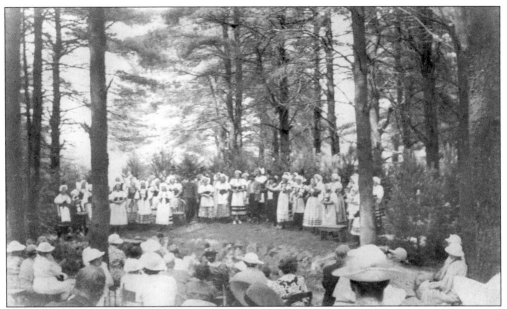

Horace N. Killam established the Boxford Oratorio Society in 1922. The group staged oratorios every summer until 1942, most frequently in a pine amphitheater near Kelsey's Nursery. The performances were well received, with audiences ranging from several hundred to more than 1,000. In this 1937 photograph, the Boxford Oratorio Society is performing Smetana's *The Bartered Bride*. (Courtesy of Fran Phillips.)

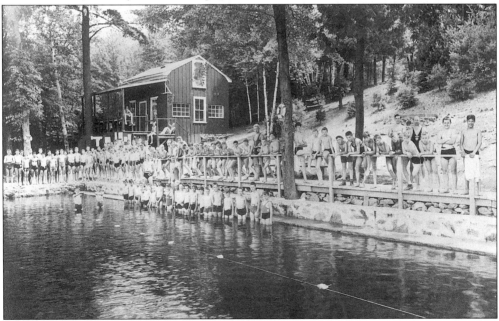

By the early 20th century, Boxford had become a favorite place to spend the summer—either in a summerhouse, a cottage on one of the ponds, or a summer camp for children. Early summer camps included the North Bennett Street School camp, the American Woolen Company camp, and Camp Alcott. Camp Rotary, with its waterfront on Stiles Pond (shown in 1937), dates from *c.* 1921. (Courtesy of Camp Rotary.)

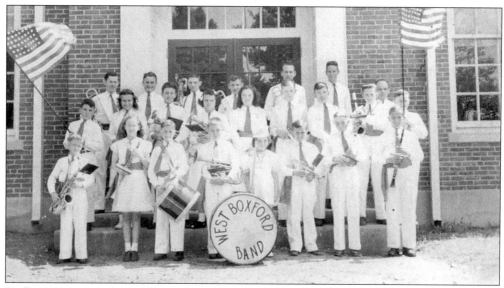

Dudley Briggs, a teacher at the Gardner Morse School, established a school band in 1940. Shown in June 1941, the band members are, from left to right, as follows: (front row) Phillip Greenler, Patricia Chadwick, James Greenler, Robert Blanchette, Judith Chadwick, Gordon Price, Warren Chadwick, and Ernest Blanchette; (middle row) Richard Scranton, Ann Price, William Clay, Denise Blanchette, Eleanor Brown, Donald Whyte, Herbert Sperry, Charles Fowler Jr., and Kenneth Chadwick; (back row) Dudley Briggs, Robert Hebb, John Greenler, Laurence Linfield, Robert Weatherbee, William Hagen, and Roy Hook. (Courtesy of Ken Chadwick.)

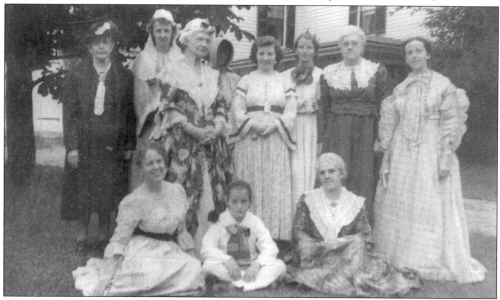

Rev. Edville Roys of the First Church established the Boxford Literary Society in 1909 to "broaden the intellectual and social life of its members and through them to make itself a power of good in the community." In costume at a 1943 meeting are, from left to right, the following: (seated) Esther Perley, Mary Lord, and Amy Parkhurst; (standing) Bertha Lane, Ella Walsh, unidentified, unidentified, Barbara Millen, unidentified, Rosamond Lord, Geraldine Moore, and Margaret Lane.

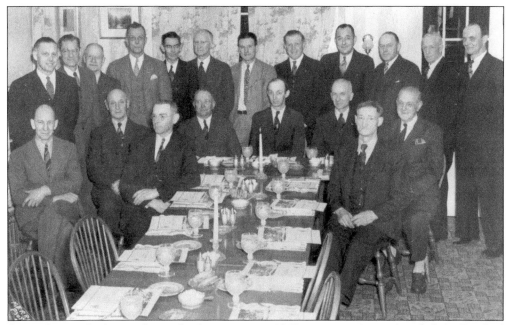

Coinciding with the purchase of a fire engine in 1942, a group of men founded the Boxford Firemen's Association. At a 1944 meeting at the Towne Line House they include, from left to right, the following: (seated) Fred Hardy, Walter French, Stanley Hills, Dimon Lockwood, Archie French, Franklin Roberts, George Stearns, and Ray Herrick; (standing) Norman Hoogerzeil, Albert Gale, George Parkhurst, "Hap" Moore, Howard Butler, Harry Trask, Tom Cargill, Henry Nason, Larry Bain, Fred Vaughn, Raymond Perley, and Clinton French.

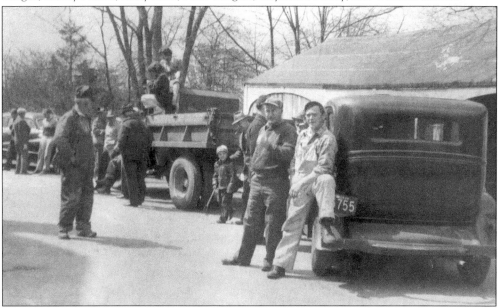

The West Boxford Improvement Society was active in the early 1900s and was responsible for naming many of the roads in West Boxford. The group was revived in 1930 and established an annual spring clean-up day. Shown c. 1945 in front of the old horse sheds at the Second Church is Monty Perkins leaning against Lester Hagan's car. (Courtesy of Ken Chadwick.)

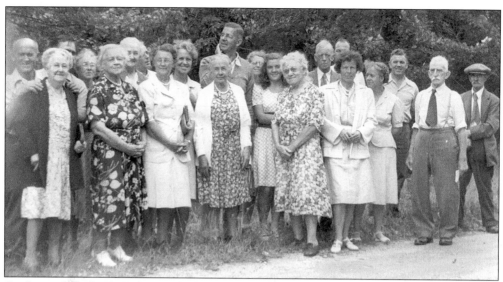

On September 13, 1947, the Boxford Historical Society took a pilgrimage to look at the 8-mile tree marker installed by John W. Parkhurst. Shown, from left to right, are the members who went on the trip: James Crosby, Bertha Crosby, Bertha Perley, Charlotte Colby, Georgianna Ayers, Milton Lord, Ethel Killam, Anna Haynes, Winthrop Haynes, Bertha Lane, Beulah Woodcock, Jane Richard, Alice Austin, Raymond Perley, Robert Elliot, Rosamond Price, Esther Perley, John R. Parkhurst, John W. Parkhurst, and Charles W. Paul.

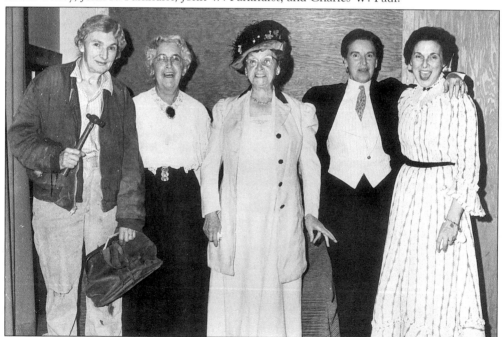

Elizabeth Sanborn Pearl was an avid historian and writer, and many of her plays incorporated her knowledge of local history in their plots and character names. One of her plays, *James Henry Kimball*, was performed by the Grange in 1962. The actresses include, from left to right, Priscilla Fowler, Elizabeth Pearl, Faye Weatherbee, Doris Hill, and Alice Barrows. (Courtesy of Ken Chadwick.)